To ♡ ⟨...⟩
our 1996 and 2000 trips
to Nfld.

Love
Mummy &
Daddy

25. VIII. 2000

Newfoundland

S O U V E N I R

Newfoundland
SOUVENIR

JOHN DE VISSER

The BOSTON
MILLS PRESS

CANADIAN CATALOGUING IN PUBLICATION DATA

De Visser, John, 1930–
ISBN 1-55046-203-2

1. Newfoundland - Pictorial works. Title.
FC2162.D48 1997 971.8'04'0222 C97-930495-4

Design by Gillian Stead
Printed in Hong Kong

First published in 1997 by
THE BOSTON MILLS PRESS
132 Main Street
Erin, Ontario
N0B 1T0
Tel 519-833-2407
Fax 519-833-2195

An affiliate of
Stoddart Publishing Co. Limited
34 Lesmill Road
North York, Ontario, Canada
M3B 2T6

The photographs in this book
were taken using Nikon cameras and Kodak Ektachrome and Fujichrome Velvia films.

The publisher gratefully acknowledges the support of the Canada Council and
Ontario Arts Council in the development of writing and publishing in Canada.

BOSTON MILLS BOOKS are available for bulk purchase for sales promotions, premiums,
fundraising, and seminars. For details contact:

SPECIAL SALES DEPARTMENT, Stoddart Publishing Co. Limited, 34 Lesmill Road,
North York, Ontario, Canada M3B 2T6 Tel 416 445-3333 Fax 416 445-5967

For Dorothy

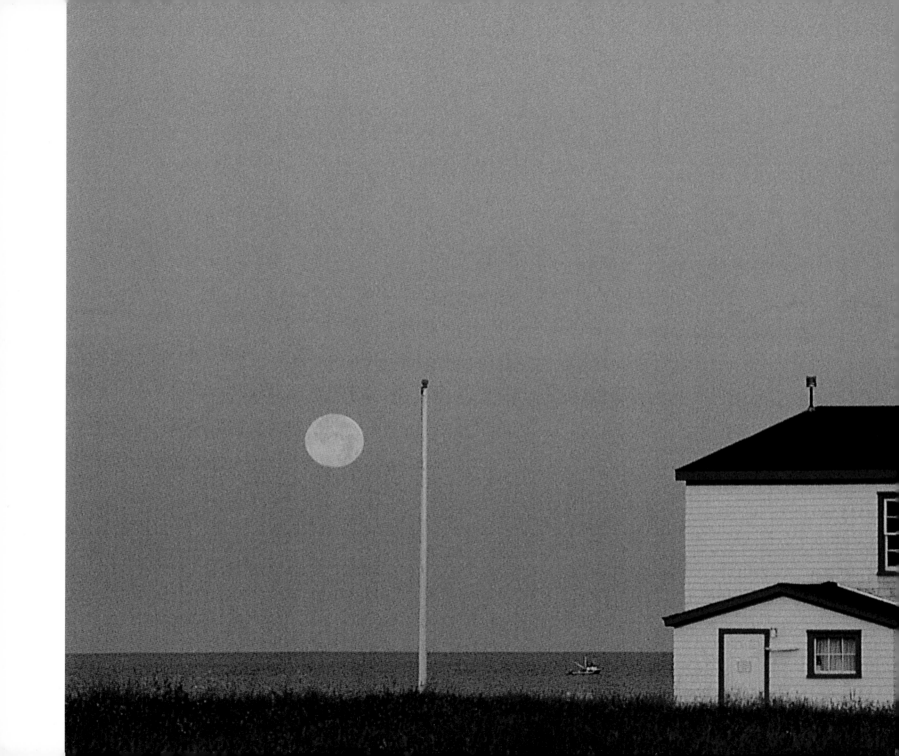

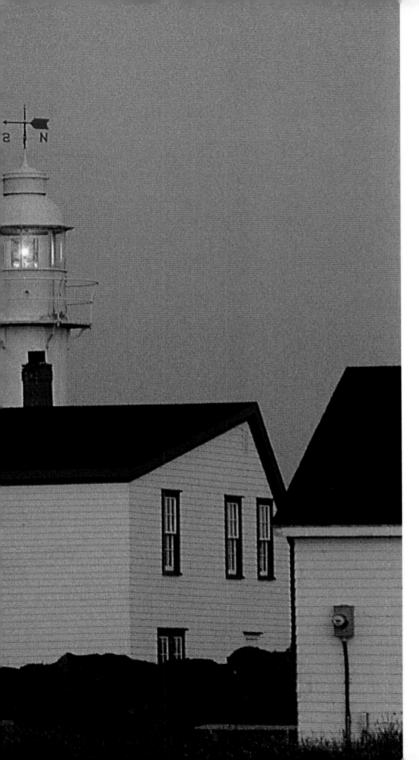

PREFACE

During my forty-plus years as a freelance photographer, I have had the extreme good fortune to travel what feels like every square inch of this great country. But without a doubt, Newfoundland is my favourite province.

For a photographer, Newfoundland has everything: mountains, lakes, rivers, icebergs, a coastline with dramatic ocean views, picturesque outports, historic places, abundant wildlife, weather of all possible — and sometimes impossible — kinds, and everywhere, the greatest people you could ever wish to meet.

My first trip across the island was in 1964, before the Trans-Canada highway was finished. That year, Premier Joey Smallwood posted signs that read: "We'll finish the drive in '65, thanks to Mr. Pearson!" This postponed completion date meant mile after mile of driving over crushed rock. In fact, when I rented a car from an agency in St. John's, they loaded eight spare tires into its trunk and gave me a list of dealers along the route in case I needed more. The Trans-Canada is still the only highway

HISTORIC LOBSTER COVE LIGHTHOUSE, NEAR ROCKY HARBOUR IN BONNE BAY, GROS MORNE NATIONAL PARK.

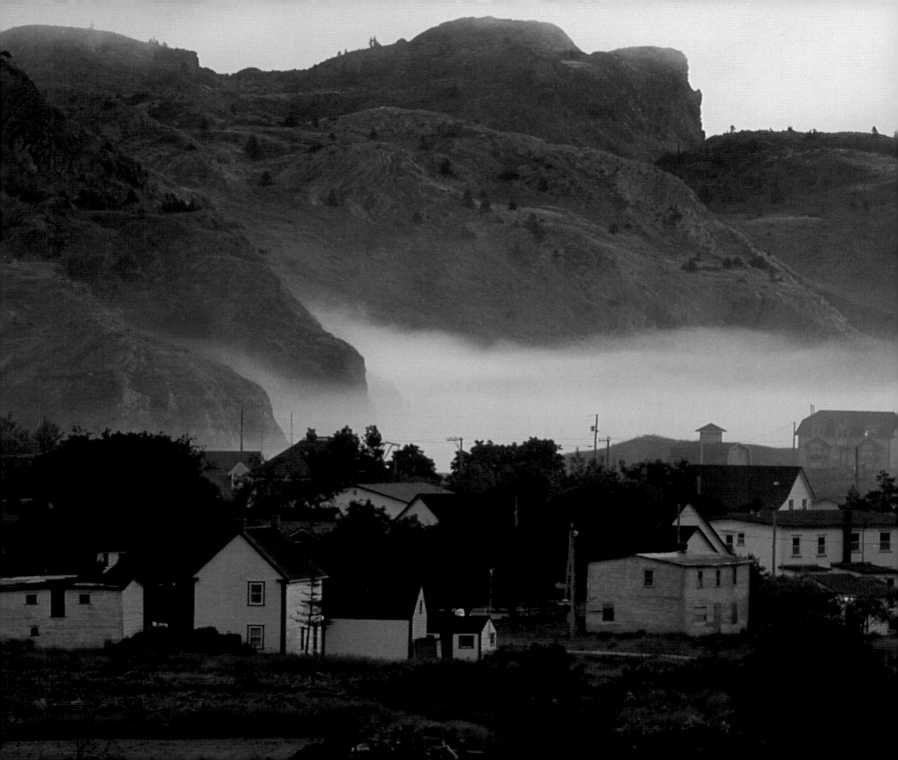

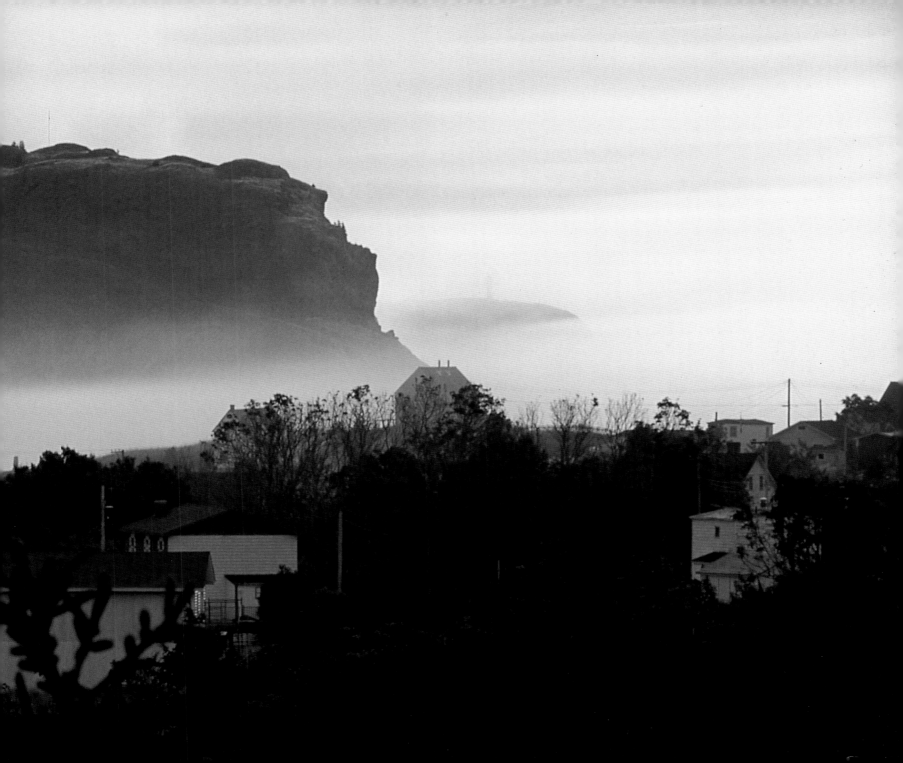

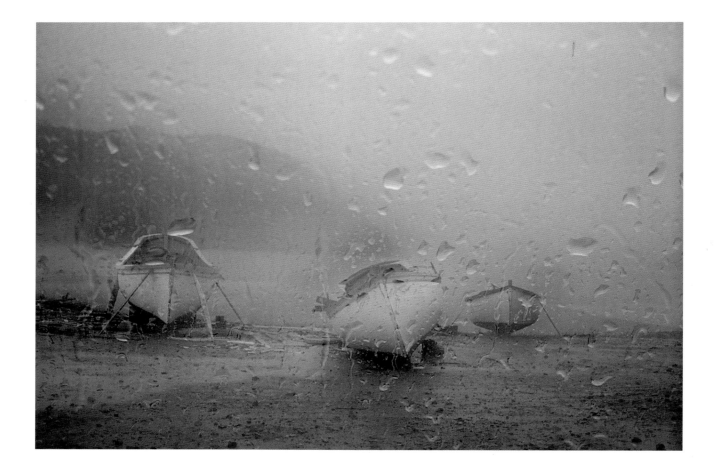

ABOVE: HAMPDEN, IN WHITE BAY, WAS ONCE A BUSY WHALING CENTRE.

PRECEDING PAGE: BRIGUS, ON CONCEPTION BAY, CAN TRACE ITS ORIGINS TO THE JOHN GUY SETTLEMENT OF NEARBY CUPIDS IN 1610.

across the entire island, but it is certainly a much easier and more pleasant drive today.

I started working on my first Newfoundland book in February of 1967, in the Burgeo area on the south coast. For most of the first two weeks of my visit, whenever I walked along one of the roads, children playing outdoors would invariably scurry indoors or hide behind the nearest snowbank when they saw me coming. I took this to be shyness. The truth was more alarming.

Because Burgeo was then, and remains, the central town in the area, it had a Royal Canadian Mounted Police outpost that served half a dozen communities. The lone Mountie in charge of the outpost was known locally as "The Man." A mother whose child was not eating his or her dinner, or who was otherwise misbehaving, might threaten that she was going to get "The Man" to take the child away! A complete stranger in such a small community was an even better bogeyman — especially in cold, dark February. I was terrifying children without my knowledge.

After a couple of weeks, a young girl playing outside her house looked up at me as I was going by and said, "Hi, John!" Everything was just fine between Newfoundland and me after that.

I love the place. Back in the 1970s, Premier Smallwood asked if I would like to spend a year in Newfoundland photographing the island over the four seasons. Nothing came of the invitation at the time, but, yes, I *would* like to.

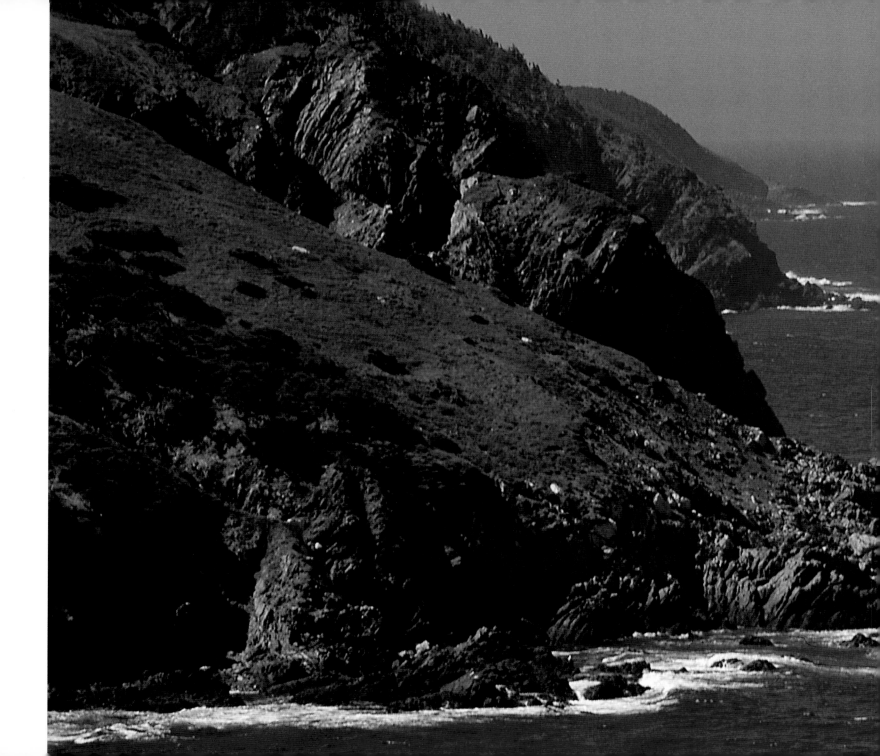

FOREWORD

hen John Cabot (Giovanni Caboto) sighted the coast of Newfoundland on June 24, 1497, his first words were, as legend has it, "O, Bueno Vista." If they were not, they should have been, for Cabot and the crew of the *Matthew* had just discovered, rising out of the roiling ocean, the steep and stately cliffs of a beautiful land that would become known as Bonavista. That first impression is as overwhelming today as it was five hundred years ago, whether that rocky promontory is outlined in sharp detail on a clear day or looms eerily, nearly hidden in thick, grey fog.

But it was not the beauty of Newfoundland that initially brought people to its shores. As early as 5500 B.C. (some sources say 7,000 B.C.) Maritime Archaic people were hunting and fishing in Labrador. Over the ensuing centuries, their descendants, along with other nomadic native people, moved into Newfoundland in pursuit of the seasonal catch. Burial sites at Port aux Choix on the island's northern arm and at L'Anse Amour in southern Labrador tell something of their existence. About A.D. 1000, Viking explorers from Iceland and Greenland reached Labrador

THE RUGGED COASTLINE OF THE SOUTHERN AVALON PENINSULA, NEAR GOOSEBERRY COVE.

and settled briefly at the tip of Newfoundland's Great Northern Peninsula at L'Anse aux Meadows. (There is still some speculation that this forbidding site was the legendary Vinland.) The Beothuk, descendants of the earlier nomadic aboriginal people, lived on the island's abundant resources of land and sea until they encountered the Europeans. The newcomers not only encroached on their territory, but also persecuted them and carried diseases to which they had no resistance. (Shawnadithit, the last surviving Beothuk, died of tuberculosis in 1829, at age twenty-eight.)

By the fifteenth century, European explorers in search of a route to the riches of the East had found instead these fabulous fishing grounds. Basque, French, Portuguese, Spanish and British vessels soon sought out what became known as the world's most prolific fisheries. It was said that cod were so abundant that you could scoop them up out of the ocean in a basket.

Following Christopher Columbus's discovery of the "Indies" (the continent of North America) in 1492, there was great interest, particularly in Spain and Portugal, in further exploration. Cabot, a Venetian of Genoese origin, unable to get support in Spain and perhaps doubting that Columbus had discovered the Indies, went to England, where he sought and received letters patent from Henry VII for a voyage of discovery. Relations between Spain and England were fragile. The English king and Cabot were both aware that the new lands to which the explorer would sail had not been granted to Spain by the 1493 Papal Bull, which divided the world between Spain and Portugal. These regions were, in effect, up for grabs.

Cabot left Bristol in May 1497 aboard the *Matthew*, built in the port of Bristol, with a crew of twenty or so. On June 24 they sighted land at the tip of Cape Bonavista, Newfoundland, where they went ashore. Cabot was given power to "find, discover, and investigate whatsoever islands, countries, regions or provinces of heathens and infidels . . . [and to] conquer, occupy and possess. . . [them]." Shrewdly, however, the King demanded a "fifth part of the whole capital gained." On his return, Cabot received £10 from a grateful King Henry, a gift "to hym that founde the new Isle." Cabot was acclaimed. It was assumed that he had found "the country of the Great Khan." But his triumph was short-lived. Conflicting accounts of a voyage the following year suggest that his ship and four others disappeared and were never heard of again.

Jacques Cartier arrived in 1534, making a partial tour of Newfoundland and Labrador (and that was

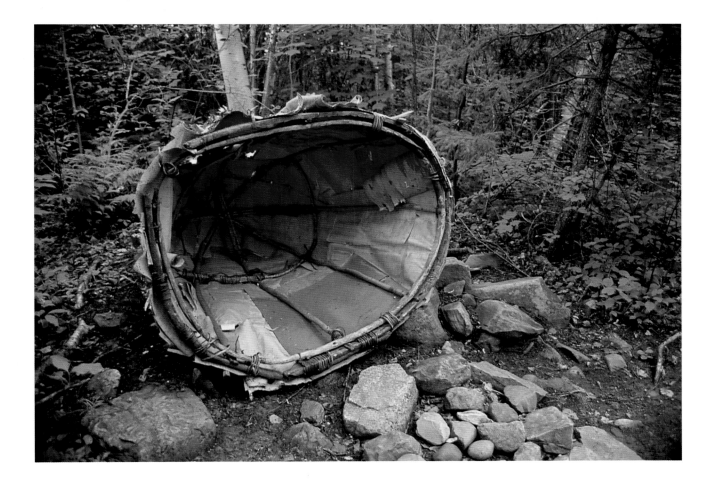

ABOVE: A birchbark sweat bath at the Beothuk village in Grand Falls:

FOLLOWING PAGE: L'Anse aux Meadows is the National Historic and UNESCO World Heritage Site where, a thousand years ago, Leif Eriksson established a Viking settlement. The outlines of the settlement buildings are easily visible in the soft, boggy ground. Adjacent is a reconstructed village complete with sod huts and replicas of Viking boats and equipment.

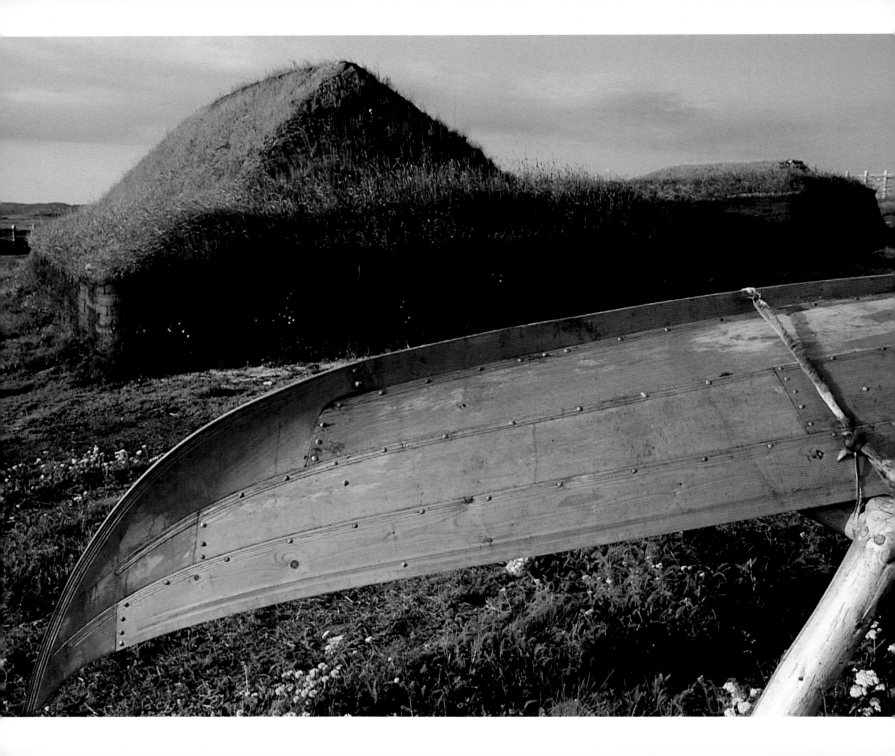

when he described Labrador as "the land God gave to Cain"). When he returned in 1535 he sailed around Newfoundland, finding the passage between it and Cape Breton, proving that Newfoundland was indeed an island.

Then, in 1583, bearing a charter from Elizabeth I of England, Sir Humphrey Gilbert sailed triumphantly into St. John's harbour and, although he found Spanish and Portuguese vessels moored there along with the British, claimed Newfoundland and two hundred leagues to the north and south for his queen in perpetuity. He also pronounced the Church of England the official religion and decreed that no opposition or disrespect for the Queen would be permitted. (Offenders were subject to penalties that ranged from having their ships seized to having their ears cut off.)

For the next two and a half centuries, Britain's West Country merchants, familiar with the winds and ways of the Atlantic, took control of the commercial life of Newfoundland. The pursuit of the humble cod led their vessels from Poole and other ports in England's West Country to Newfoundland's shores. It was in their interest to discourage settlement and thus preserve the riches of the cod fishery for themselves. They persuaded the British Crown and parliament to enact laws to this effect.

Here, unlike in Britain's other colonies, there were no enticements to settle — no offers of free land, no provisioning for a year, no promise of a governor to preserve law and order. Quite the opposite. In 1634 it was decreed that the captain of the first British ship to arrive in a harbour each spring would be admiral and governor of the harbour for that season. Harsh measures were the order of the day — houses were burned, and any individuals who chose to stay were forbidden to build within six miles of the shoreline, and threatened with deportation.

In spite of all this, some stalwart people wintered over. Immigration began and reached its peak during the late eighteenth and early nineteenth centuries. (In the early years of the nineteenth century the population numbered 40,000. By 1891 it had reached 202,000.) Crews from West Country vessels stayed. A few merchants established a permanent residence in Newfoundland or Labrador. And since conditions in parts of the British Isles were so deplorable that anything seemed better, many men and women were willing to take their chances in a new land. Certainly that was true for the Irish.

The Irish came initially to work as fishermen and crew for the summer fishery. When permanent

settlement began in the eighteenth century, many were brought out as servants. A few were merchants. In the first three decades of the nineteenth century alone, as many as 30,000 to 35,000 Irish immigrated to Newfoundland. Eventually they made up nearly fifty percent of the island's population. Their numbers were so great that it became popular to call Newfoundland "John Bull's other Ireland."

The Irish suffered in Newfoundland — particularly as their numbers increased. With centuries of English-Irish antagonism fuelling their distrust, they found more of the same in their new home. Some were tricked and later abandoned by unscrupulous English shipowners (as were English servants as well), treated as rabble by the English establishment, encouraged in their alcoholic excesses, treated harshly in the English courts, and forbidden to attend Mass until the official establishment of the Roman Catholic church in 1784. The British accused them of being lazy, untrustworthy and prone to drunkenness. Yet the record is not as black as has sometimes been painted, and they found ample employment, many operating taverns, or working as stonemasons or carpenters, or in other skilled trades.

As the eighteenth century progressed, life for the people of Newfoundland, though still harsh, became somewhat better. The first of many naval governors arrived in 1729 (albeit only for the summer months and encumbered by the British government's anti-settlement policy). Local magistrates began to keep some semblance of order during the nine months of the year when there were neither fishing admirals nor King's ships in the harbours.

After the Treaty of Paris ended the Seven Years' War in 1763, England annexed Labrador to Newfoundland, creating a vast territory including areas that are now part of Quebec. Then, eleven years later, the British government changed its mind, and Labrador was handed over to Quebec. Finally, in another about-face, Labrador was reannexed to Newfoundland in 1809, and in March 1927 the boundary was settled in its present location.

The colony was granted representative government in 1832, with elected and appointed chambers. It proved unworkable. Responsible government, with full colonial status, arrived in 1855. Religion, ethnicity, and social status played an important part in the politics of the day, and resulted in heated exchanges in the Legislature, and occasional violence in the streets — much of it fuelled by alcohol.

Rum was the most popular tipple. It played an important and particularly destructive role in eighteenth-

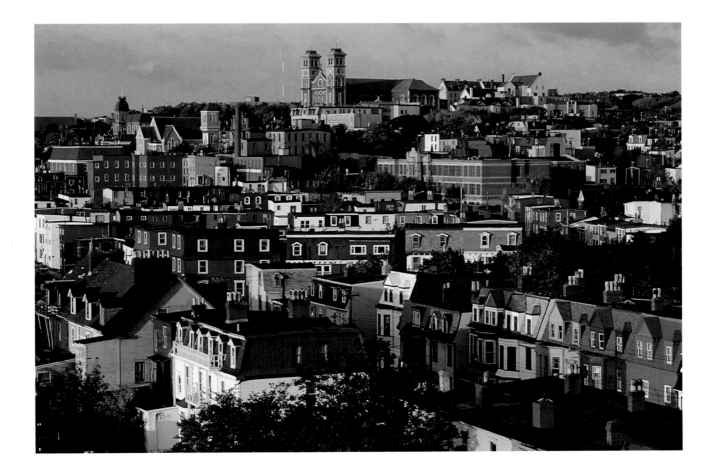

ABOVE: OLD ST. JOHN'S BRIGHTLY PAINTED HOUSES LEAD UP TO THE CITY'S ROMAN CATHOLIC CATHEDRAL.

FOLLOWING PAGE: SUNRISE AT THE CAPE RAY SHORE.

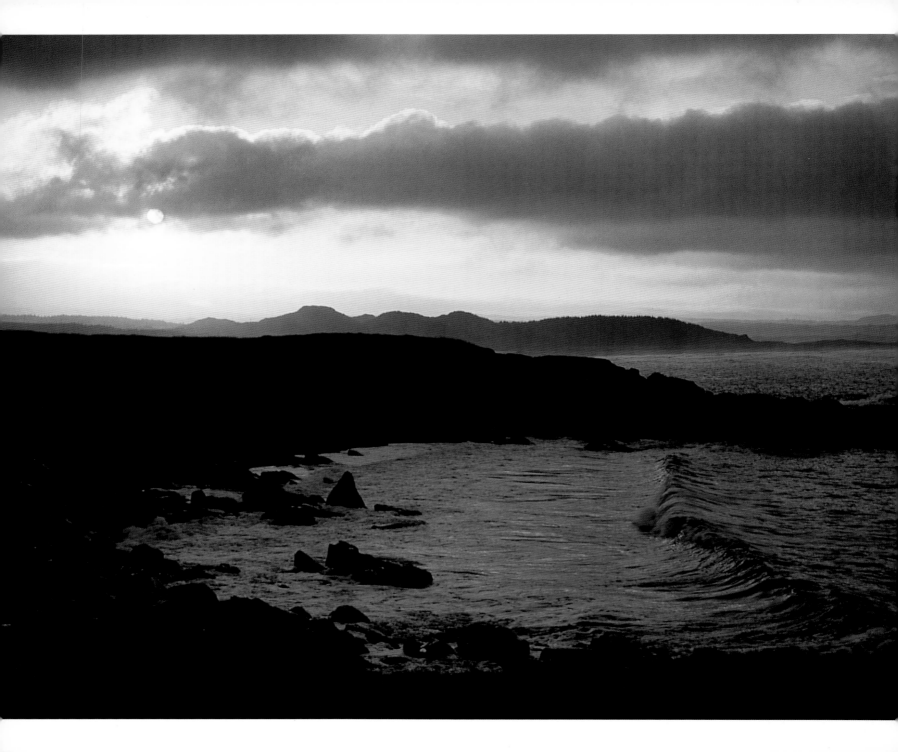

and nineteenth-century Newfoundland, as it did elsewhere. Even the young imbibed. The quantity of spirits consumed in St. John's in the early eighteenth century was of proportions that have been called "amazing, almost incredible." About 220,000 gallons of rum alone were imported for a population of only 20,000 — eleven gallons per head for everyone in Newfoundland. And then there was brandy, gin, wine, beer, and cider — eleven gallons per head was the average here. (Newfoundlanders were, of course, assisted in their intake by the many hundreds of transient fishermen from other countries). In St. John's in the early 1800s, seven hundred troops added to a social life that included balls, picnics and theatricals. Drinking was a way of life, with every man "supposed to absorb at least a bottle of port at supper or dinner."

Newfoundland has been called a "land of easy smiles," and true it is, but life has been full of tragedy as well. It is not necessary to look further than a map of Newfoundland and Labrador to sense its history. The names of towns, bays, coves, islands and tickles capture the extremes — the centuries of conflict, the rough life, and a deep sense of home.

Names such as Heart's Content, Snug Harbour, Paradise, Angels' Cove and Harbour Grace suggest the satisfaction that settlers had found in their new island home. At the other extreme, Wreck Cove, Misery Point, Breakheart Point, Bareneed, Famish Gut and Gripe Point speak of shipwrecks, loss of life, and the harsh conditions that met newcomers. Other names recall the French influence, the history of the native people, and the life on land and sea on which their very existence depended. And Newfoundlanders' innate sense of humour came to the fore when Joe Batt's Arm, Jerry's Nose, Ha Ha Bay, and Bumble Bee Bight were christened. But then there must have been days when tedium set in, with Nameless Cove and Harbour Harbour all that came to mind.

John de Visser has caught the subtle magic of Newfoundland and Labrador and the tenacious character of its people in his superb photographs. A born adventurer, he is always ready to explore — to follow a road to the sea, to seek out that telling scene that speaks volumes, to capture on film Newfoundland's rough beauty. His sense of adventure has led him to many parts of Canada and resulted in forty-five books, a legacy and a delight — as is this, his latest work.

Margaret McBurney and Mary Byers are authors of *True Newfoundlanders:*
Early Homes and Families of Newfoundland and Labrador, Boston Mills Press, 1997.

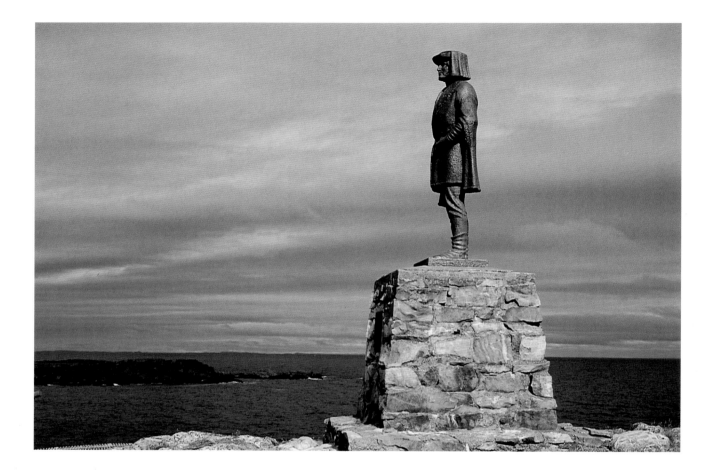

ABOVE: A STATUE OF JOHN CABOT OVERLOOKS CAPE BONAVISTA, WHERE NEWFOUNDLANDERS SAY HE MADE LANDFALL ON JUNE 24, 1497, ON BEHALF OF KING HENRY VII OF ENGLAND.

OPPOSITE: THE HISTORIC LIGHTHOUSE ON THE CLIFFS OF CAPE BONAVISTA, WHERE JOHN CABOT LANDED IN 1497.

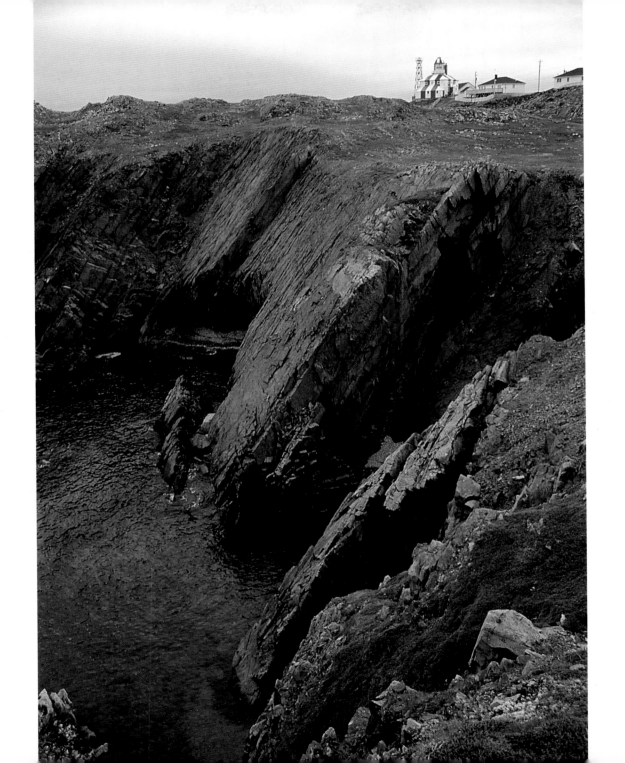

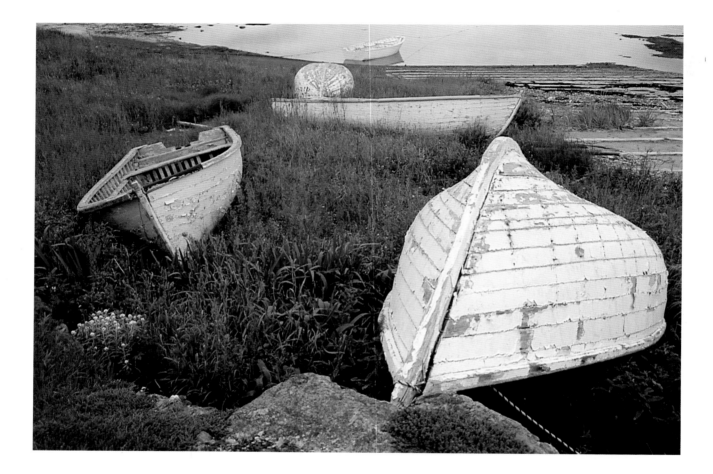

ABOVE: ABANDONED BOATS AT MUSGRAVE HARBOUR ON BONAVISTA BAY.

OPPOSITE: THE RYAN PREMISES, IN BONAVISTA TOWN, HAVE BEEN BEAUTIFULLY RESTORED. THE JAMES A. RYAN COMPANY WAS ONE OF THE MOST SUCCESSFUL FISHERY SUPPLY FIRMS IN NEWFOUNDLAND, EXPORTING COD, COD OIL, SALMON, AND OTHER GOODS.

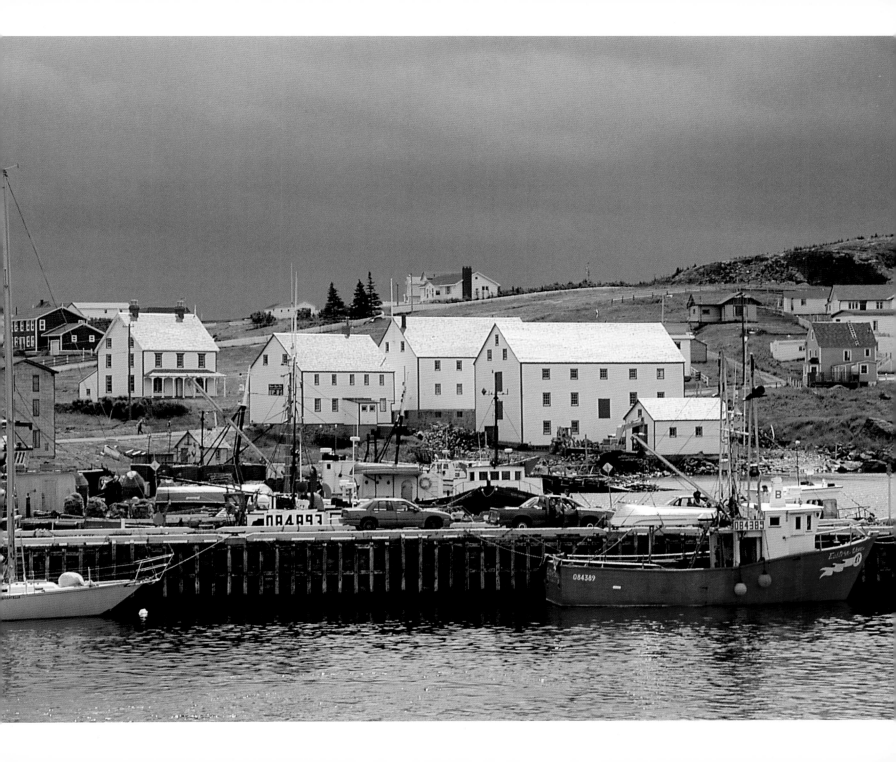

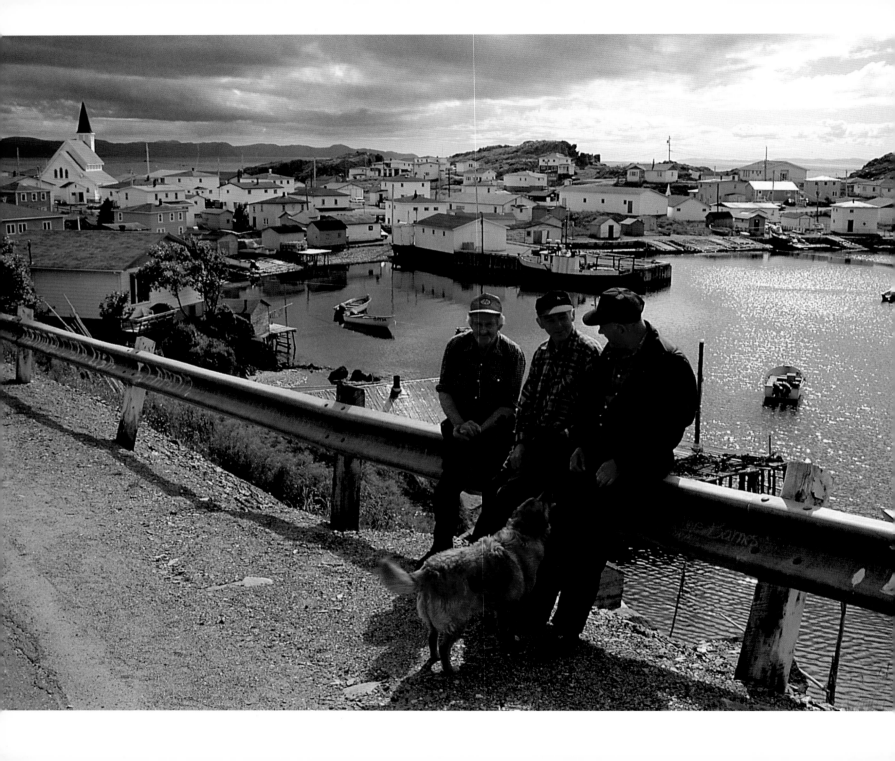

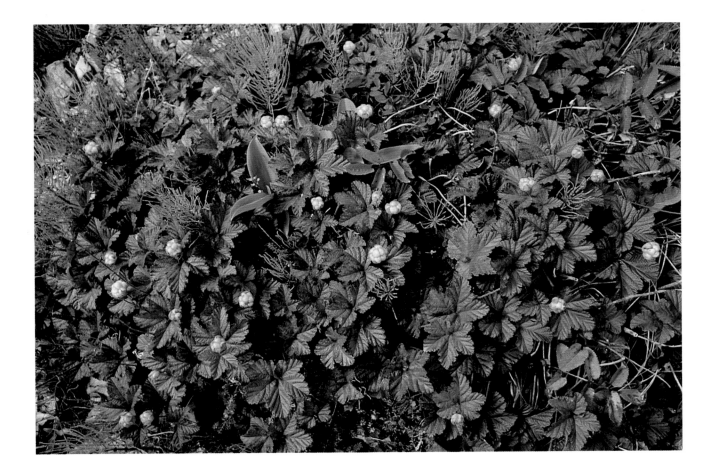

ABOVE: The native plant bakeapple — perhaps better known as the cloudberry — is a local delicacy used for pies, preserves and even liqueur.

OPPOSITE: Time out at Harbour Mille, in Fortune Bay, on the west side of the Burin Peninsula.

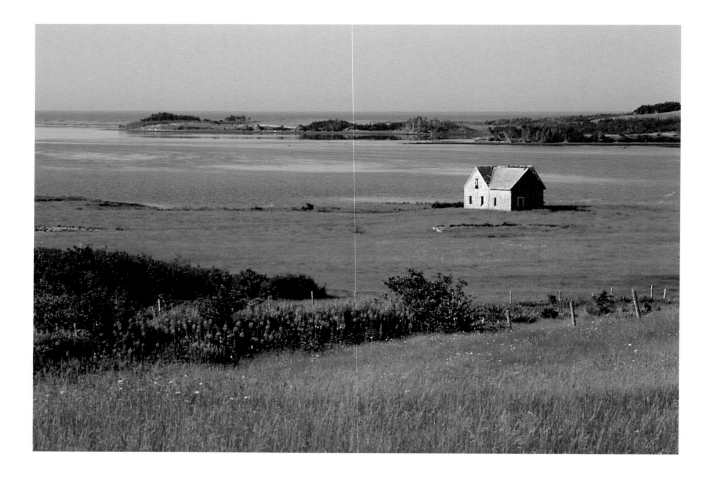

ABOVE: THE CODROY RIVER NURTURES THE ONLY MAJOR AGRICULTURAL AREA ON THE ISLAND OF NEWFOUNDLAND.

OPPOSITE: EARLY LIGHT OVER THE LONG RANGE MOUNTAINS JUST NORTH OF PORT AUX BASQUES.

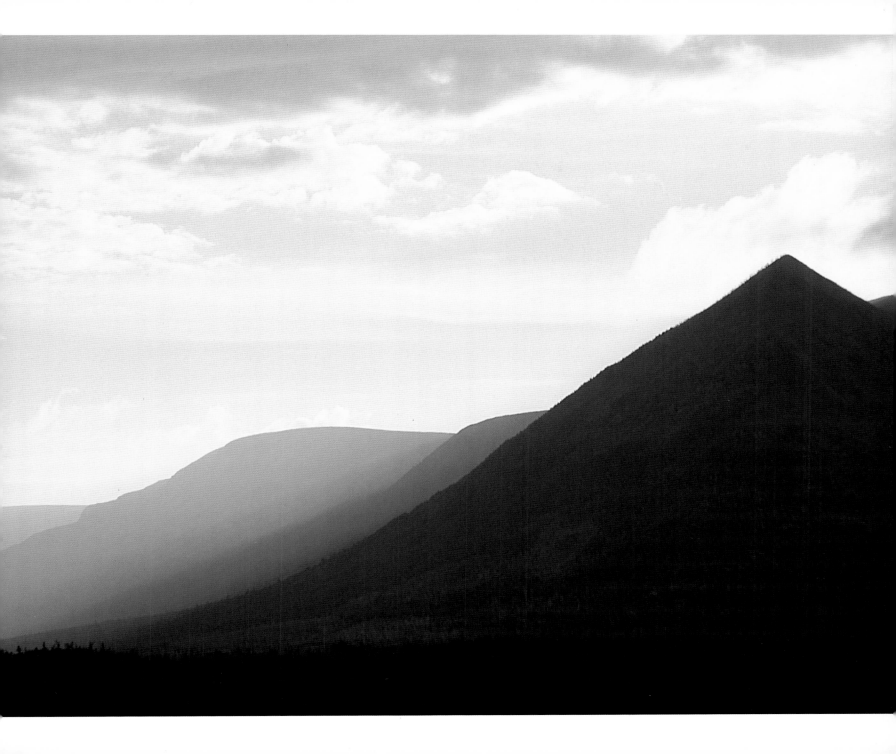

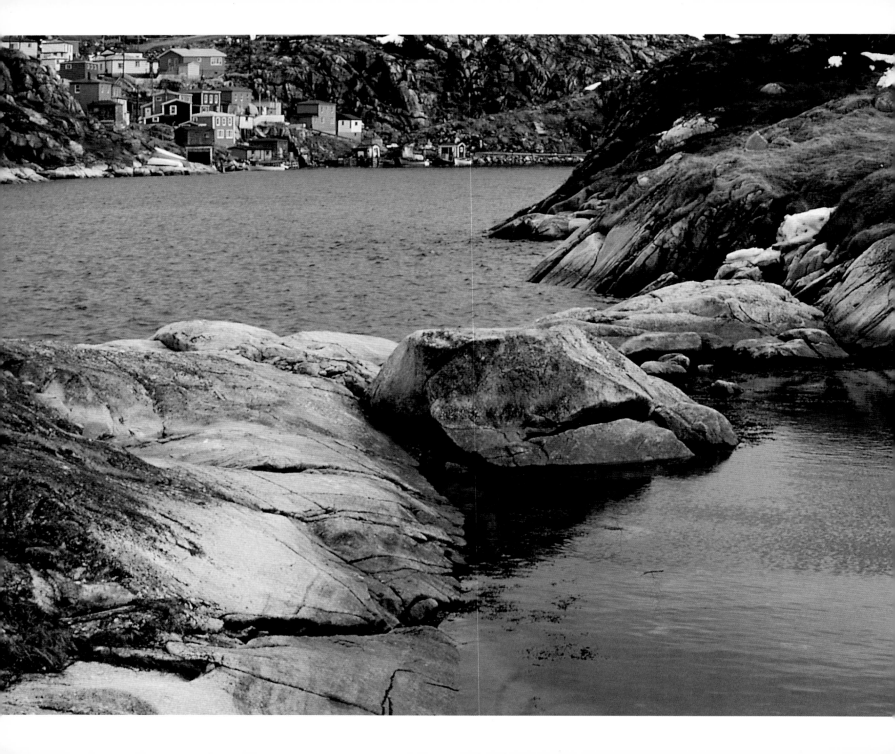

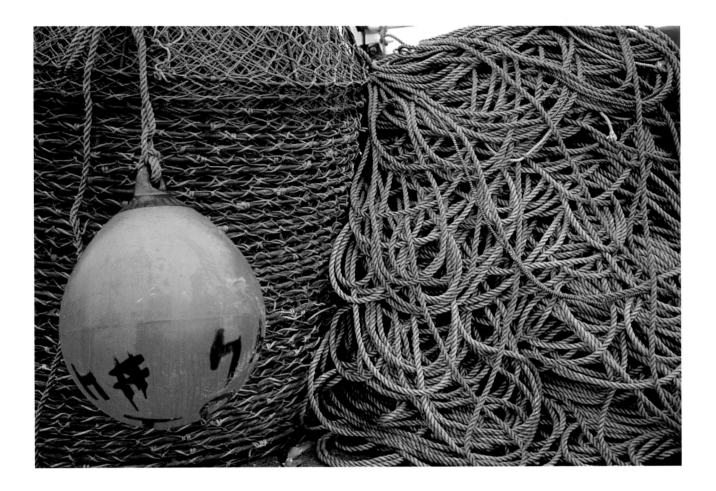

ABOVE: FISHING GEAR IN GREENSPOND HARBOUR.

OPPOSITE: ROSE BLANCH, NEXT DOOR TO HARBOUR LE COU, ON THE SOUTH COAST.

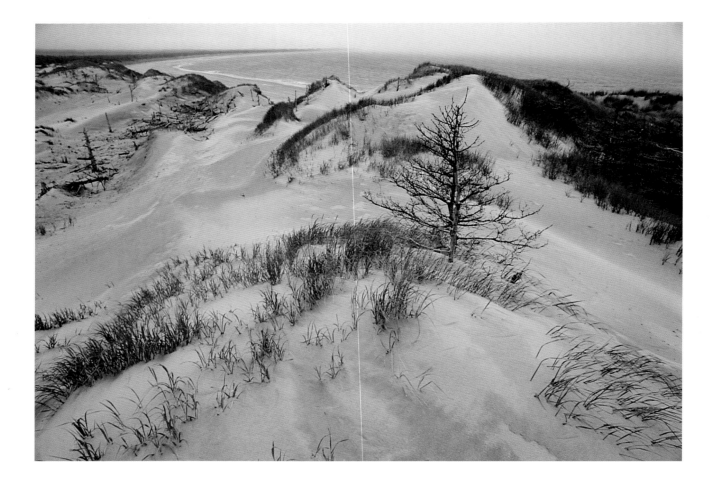

ABOVE: Sand dunes along the shore near Sally's Cove.

OPPOSITE: The distant cut in the Long Range Mountains is the entrance to Western Brook Pond, the most famous feature of Gros Morne National Park.

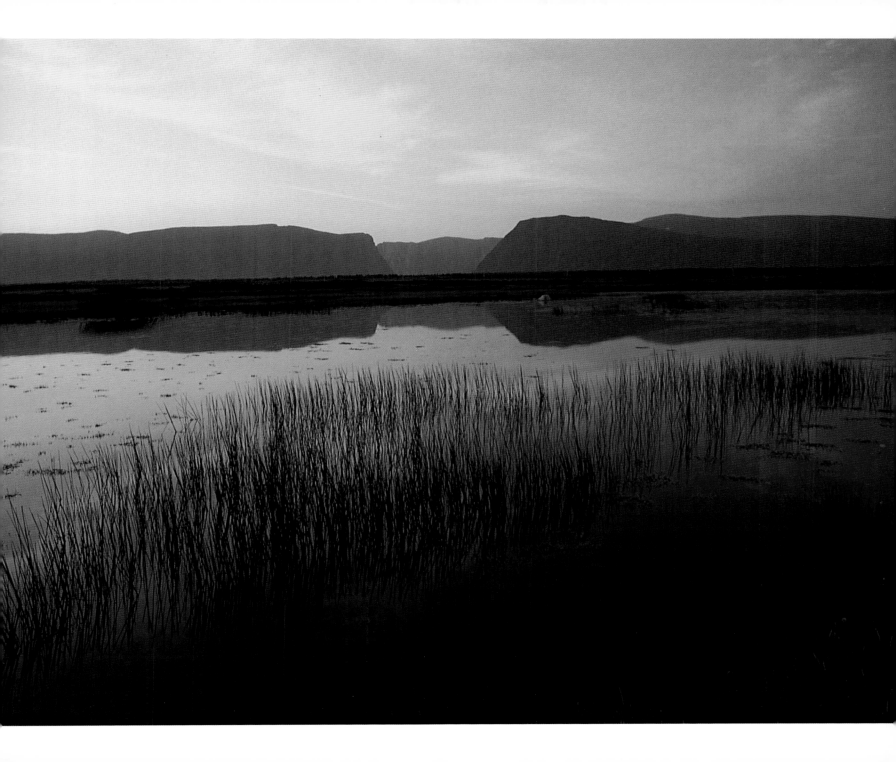

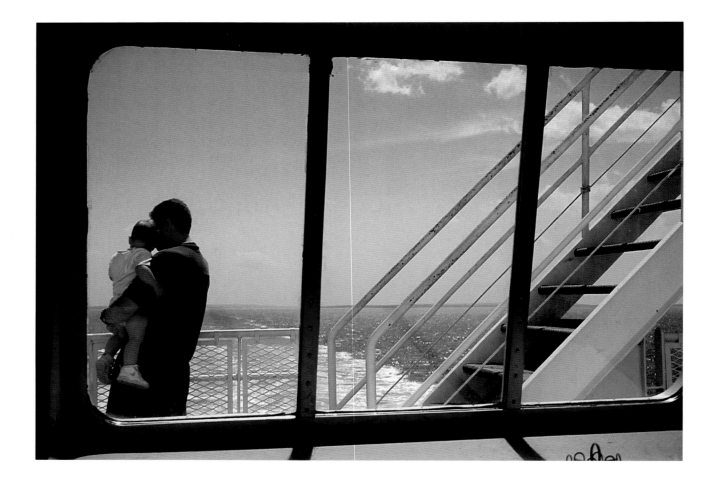

ABOVE: THE PORT AUX BASQUES FERRY LINK WITH NORTH SYDNEY, NOVA SCOTIA, IS NEWFOUNDLAND'S MAIN CONNECTION WITH THE REST OF CANADA, OFTEN REFERRED TO BY NEWFOUNDLANDERS AS "AWAY" OR "UPALONG."

OPPOSITE: FOR FERRY PASSENGERS, THE FIRST SIGN OF NEWFOUNDLAND IS THE LIGHTHOUSE ON CHANNEL ISLAND AT PORT AUX BASQUES.

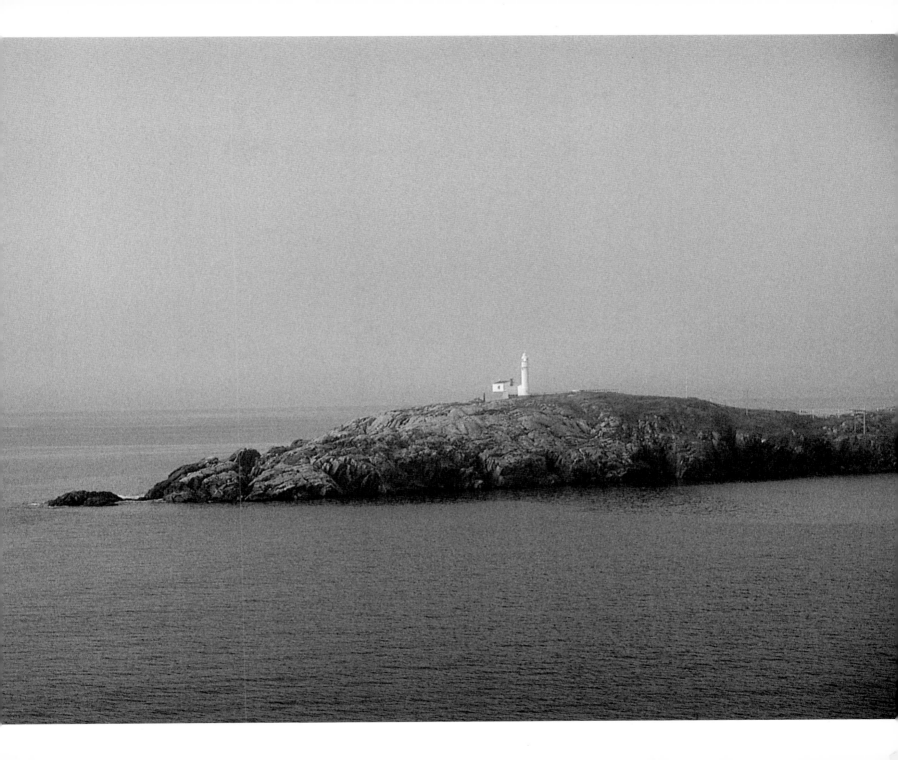

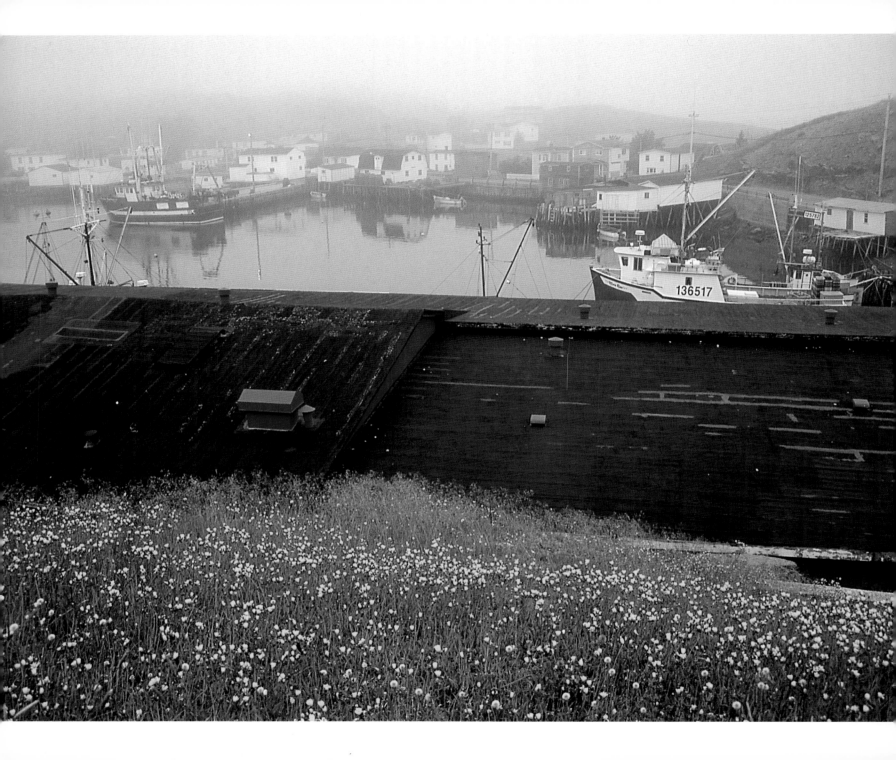

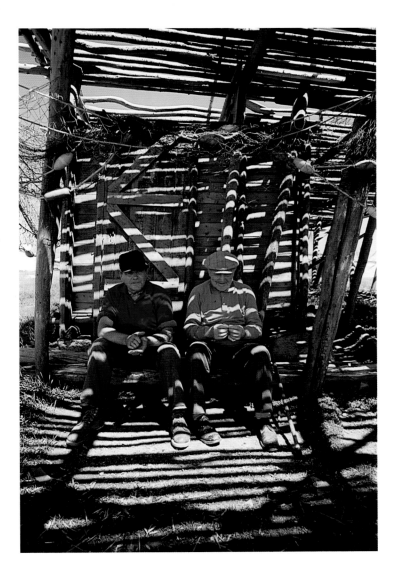

ABOVE: Bay de Verde, at the northern tip of the Avalon Peninsula, is said to date back to 1662.

OPPOSITE: Port de Grave harbour as seen from above the fish plant.

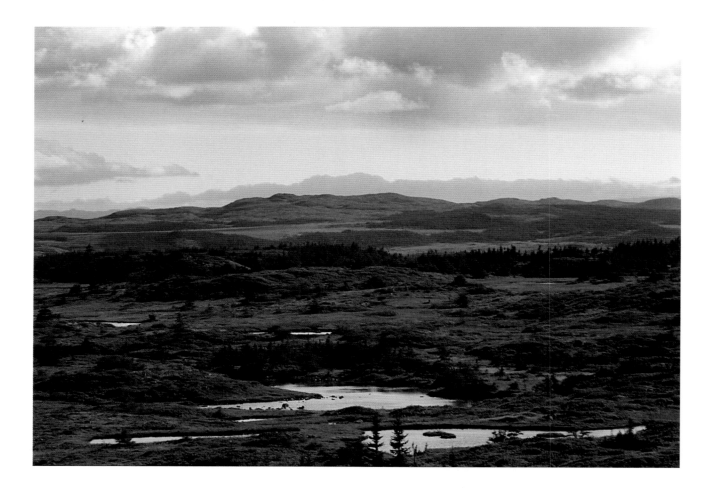

ABOVE: THE CENTRE OF NEWFOUNDLAND IS AN IMMENSE AREA OF WILDERNESS FORESTS, BARRENS, LAKES AND BOGS, POPULATED ALMOST EXCLUSIVELY BY CARIBOU AND MOOSE.

OPPOSITE: IN AUTUMN, THE WOODLAND CARIBOU MIGRATE SOUTH TO THE COAST FOR EASIER WINTER FEEDING.

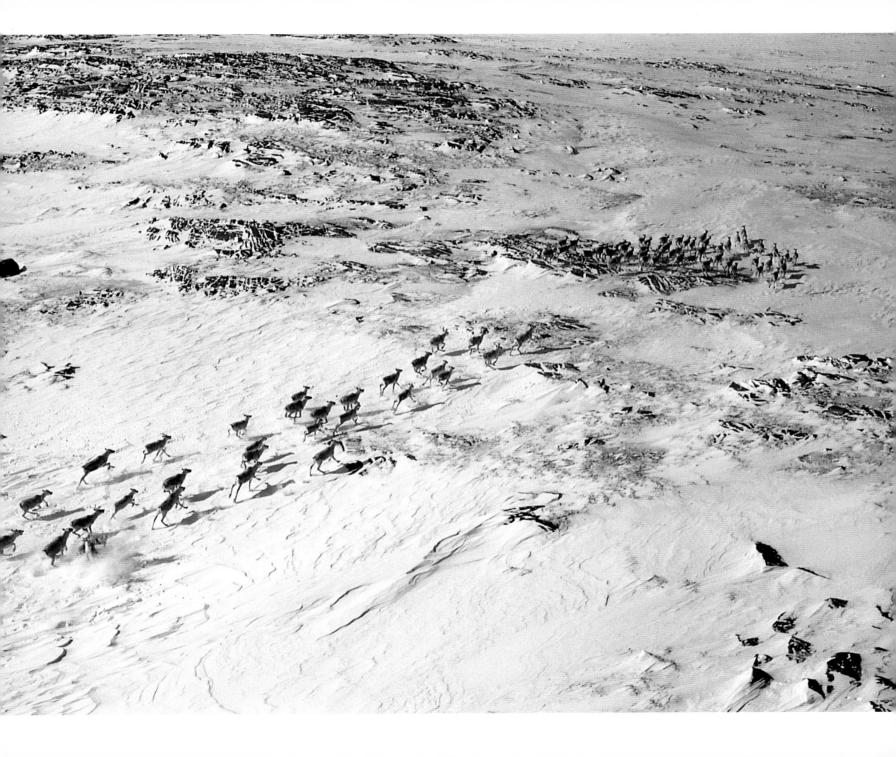

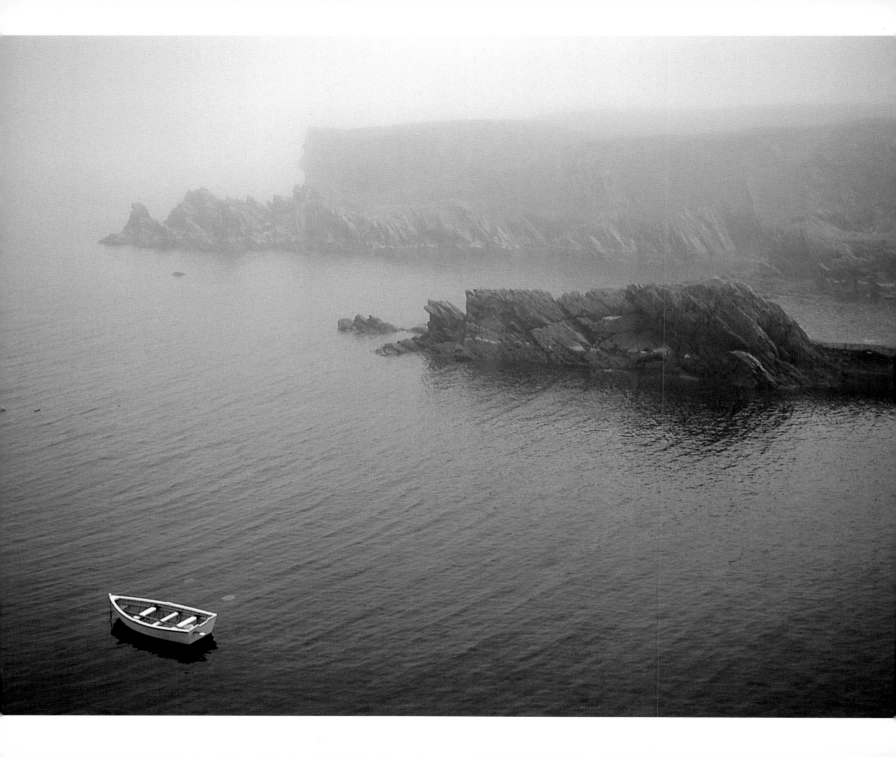

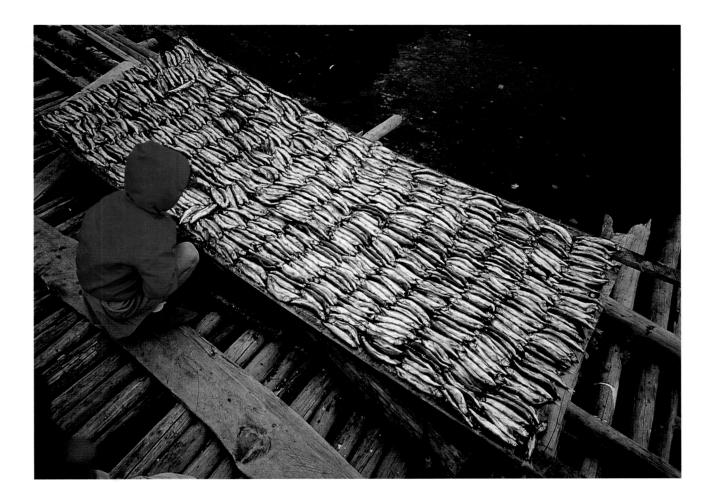

ABOVE: LARGE SCHOOLS OF CAPELIN (OR CAPLIN) COME IN TO SHORE TO SPAWN.
THESE SMALL FISH ARE SCOOPED UP BY THE BUCKETFUL BOTH FOR FOOD AND FOR FERTILIZER.

OPPOSITE : HIBB'S HOLE, NOW CALLED HIBB'S COVE, ON CONCEPTION BAY, NOT FAR FROM BRIGUS.
THERE HAS BEEN A SETTLEMENT HERE SINCE AT LEAST 1745.

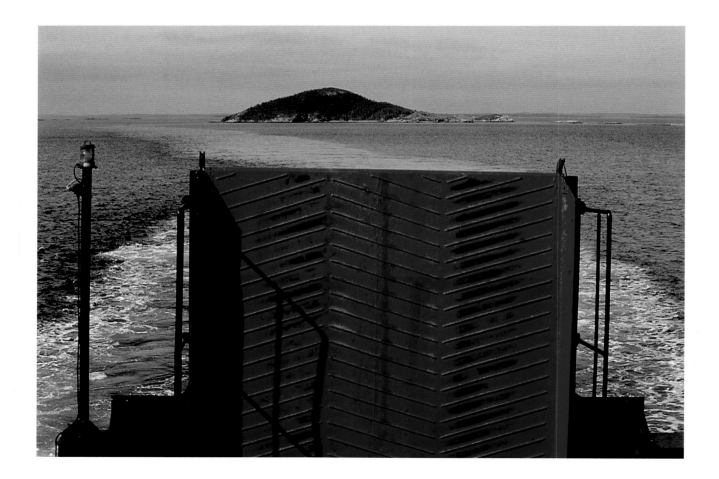

ABOVE: THE FERRY TAKES FIFTY MINUTES TO TRAVEL FROM FAREWELL, ON DILDO RUN, TO FOGO ISLAND. ONE OF THE ISLAND COMMUNITIES IS JOE BATT'S ARM, SAID TO BE NAMED FOR A MEMBER OF CAPTAIN JAMES COOK'S CREW WHO JUMPED SHIP HERE IN 1763.

OPPOSITE: FOGO ISLAND APPEARED ON PORTUGUESE MAPS AS EARLY AS 1529. "FOGO" IS FROM THE PORTUGUESE FUEGO, OR "FIRE," SOME SAY BECAUSE OF THE MANY BEOTHUK CAMPFIRES THEN OBSERVED ON THE ISLAND.

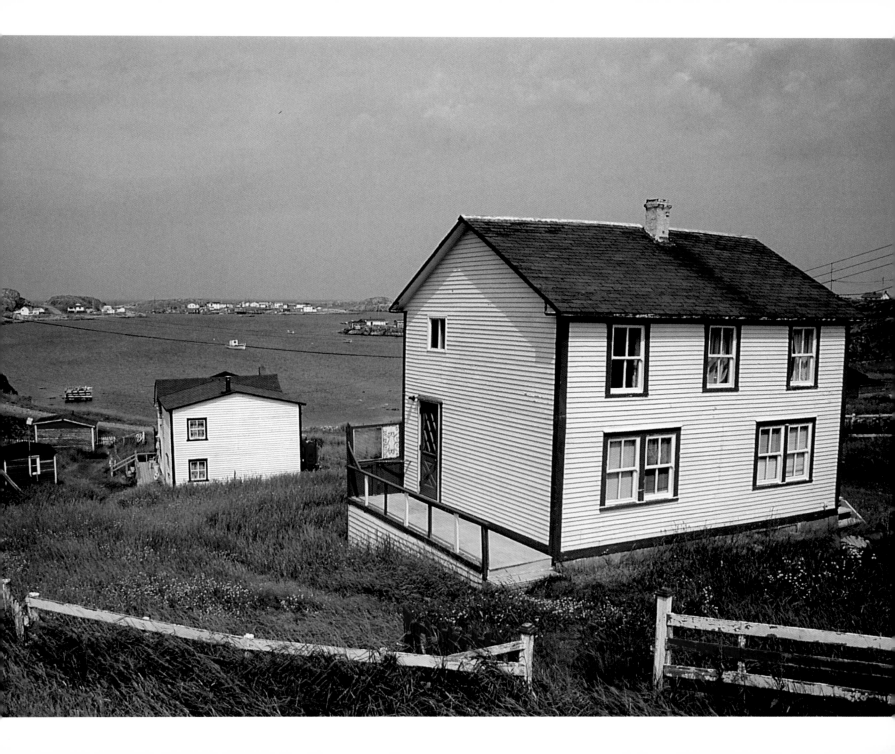

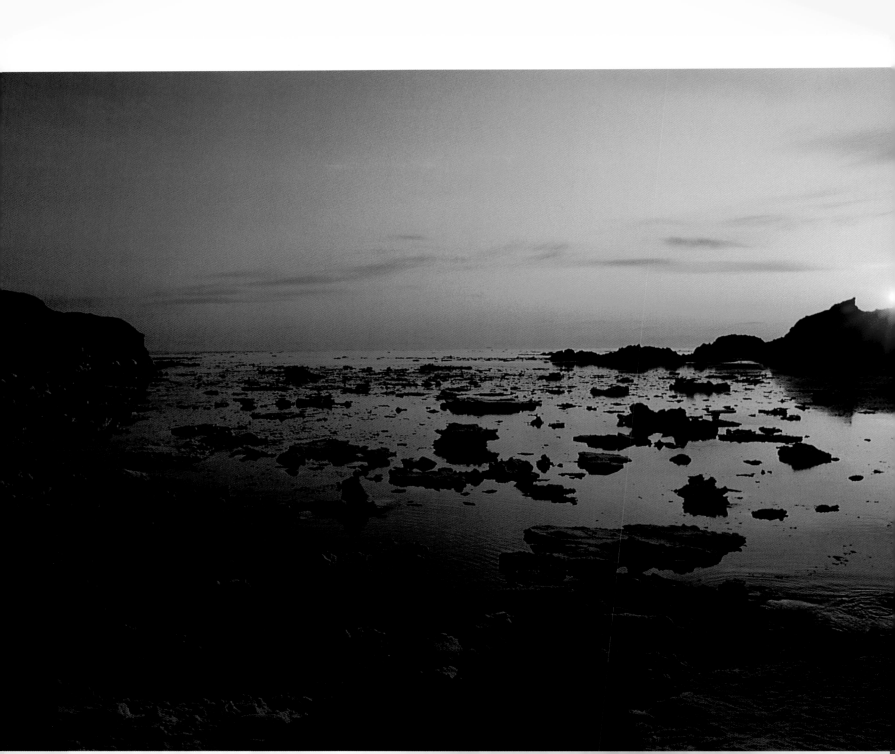

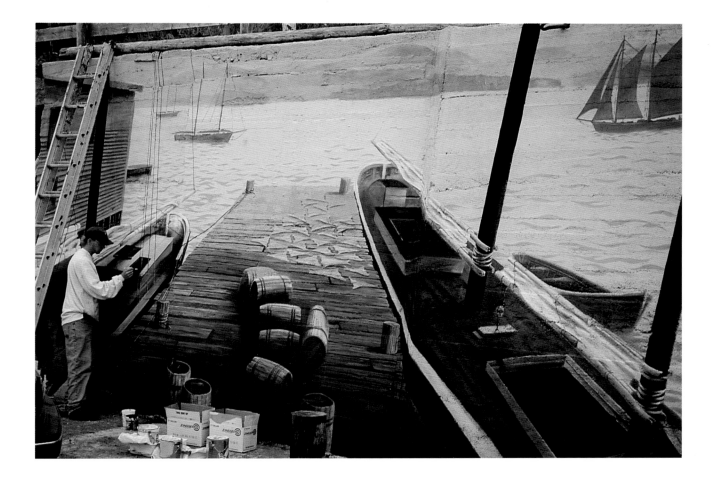

ABOVE: AN ARTIST PAINTS A TRADITIONAL SCENE ON A CLIFF WALL AT THE HARBOUR IN THE HISTORIC TOWN OF TRINITY.

OPPOSITE: ARCTIC ICE OF ALL SIZES, INCLUDING HUGE ICEBERGS, DRIFTS INTO NEWFOUNDLAND'S NORTHERN BAYS AND COVES, SOMETIMES WELL INTO THE SUMMER. THIS VIEW IS FROM LONG POINT, NEAR TWILLINGATE.

ABOVE: MANY NEWFOUNDLANDERS PAINT THEIR BOATS, LIKE THEIR HOUSES, IN BRIGHT COLOURS.

OPPOSITE: THE PICTURESQUE LITTLE OUTPORT OF HARBOUR LE COU IS AT THE END OF THE SOUTH COAST HIGHWAY,
WHICH RUNS EAST FROM PORT AUX BASQUES FOR 35 KILOMETRES.

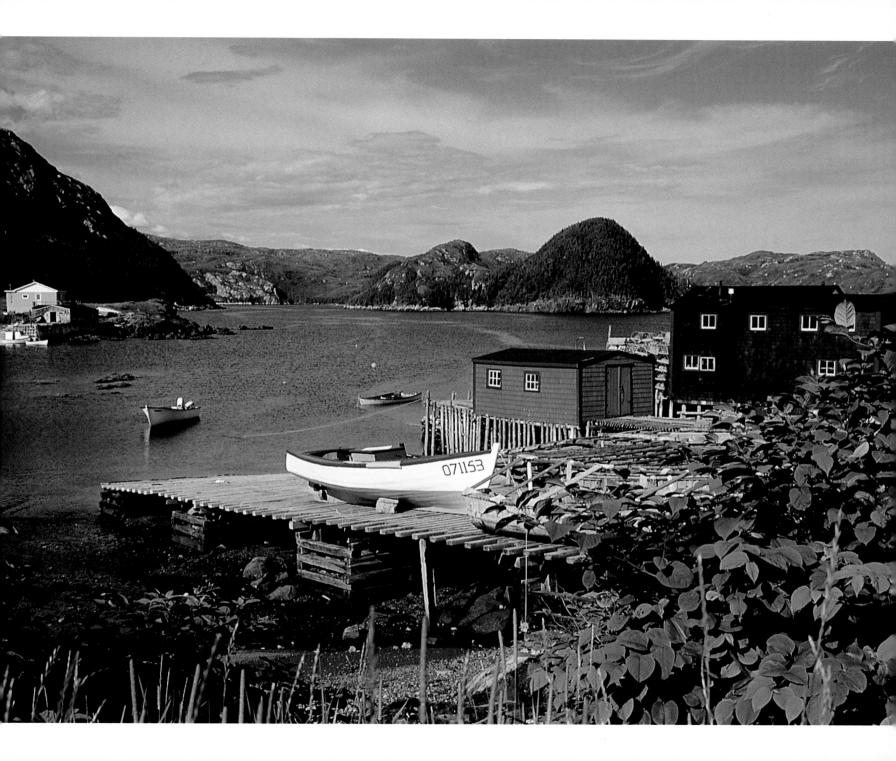

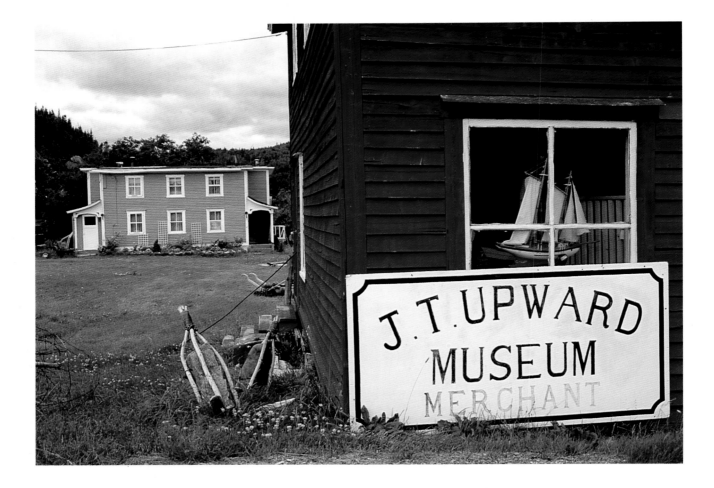

ABOVE: THE MUSEUM ESTABLISHED BY LOCAL MERCHANT J. T. UPWARD AT HARRY'S HARBOUR ON GREEN BAY.

OPPOSITE: LOOKING WEST OVER CONCEPTION BAY FROM BETWEEN ST. PHILLIPS AND PORTUGAL COVE.

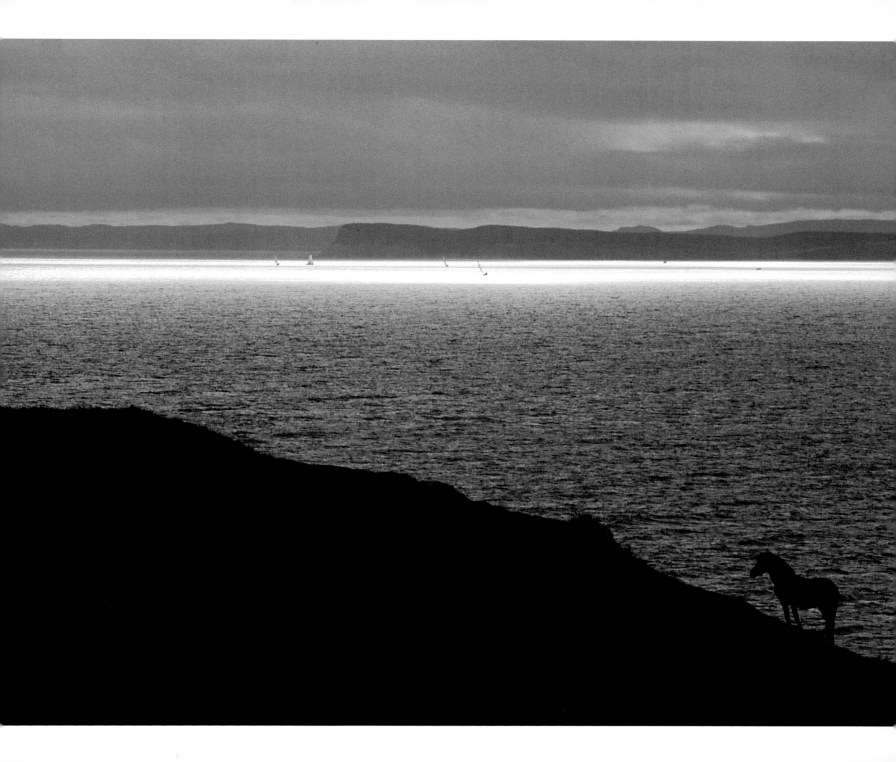

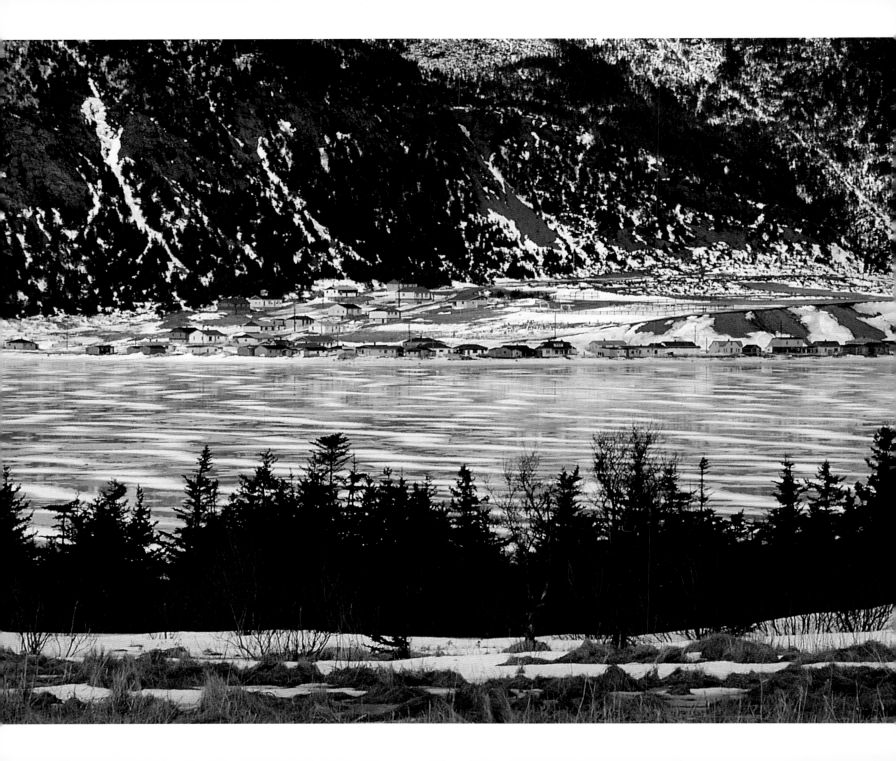

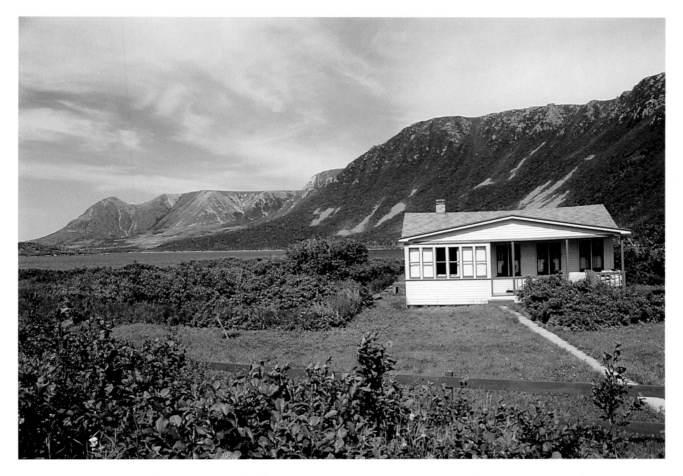

ABOVE: WRECKHOUSE (POPULATION 9 IN 1945) IS LOCATED AT THE SOUTHERN BASE OF THE TABLE MOUNTAINS, NEAR CAPE RAY. THE OFTEN GALE-FORCE WINDS SWIRLING DOWN FROM THE MOUNTAINS WERE STRONG ENOUGH TO BLOW THE *NEWFIE BULLET* RIGHT OFF THE TRACKS. LAUCHIE MCDOUGALL, WHO LIVED AT WRECKHOUSE, WAS HIRED BY THE RAILWAY TO "SNIFF THE WIND" AND TO CALL THEM IF IT WAS BLOWING TOO FIERCELY.

OPPOSITE: LARK HARBOUR, IN THE BAY OF ISLANDS, AT THE FOOT OF BLOW-ME-DOWN MOUNTAIN.

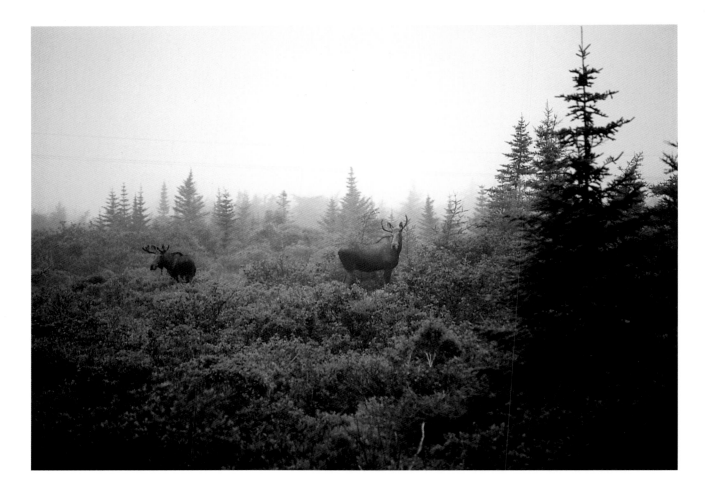

ABOVE: THE MOOSE IS NOT NATIVE TO NEWFOUNDLAND.
TWO BULLS AND TWO COWS WERE BROUGHT OVER FROM NEW BRUNSWICK IN 1904. BY THE 1980S THEIR NUMBER HAD GROWN TO 150,000.

OPPOSITE: TERRA NOVA NATIONAL PARK, IN CENTRAL NEWFOUNDLAND, COVERS ROUGHLY 400 SQUARE KILOMETRES
OF FORESTS AND BAYS, INCLUDING NEWMAN SOUND.

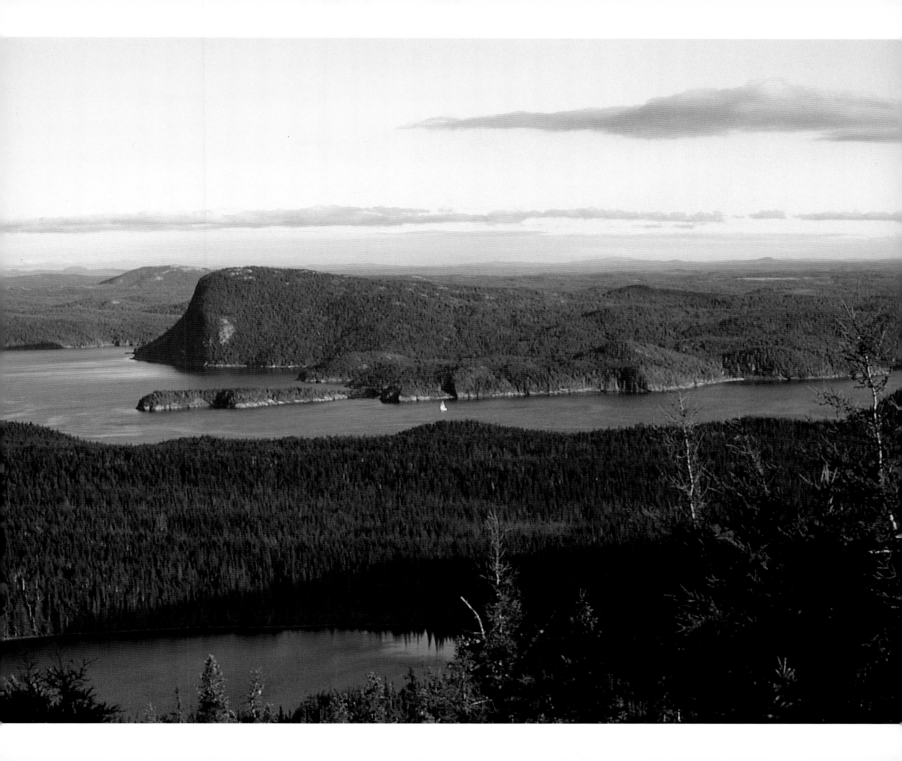

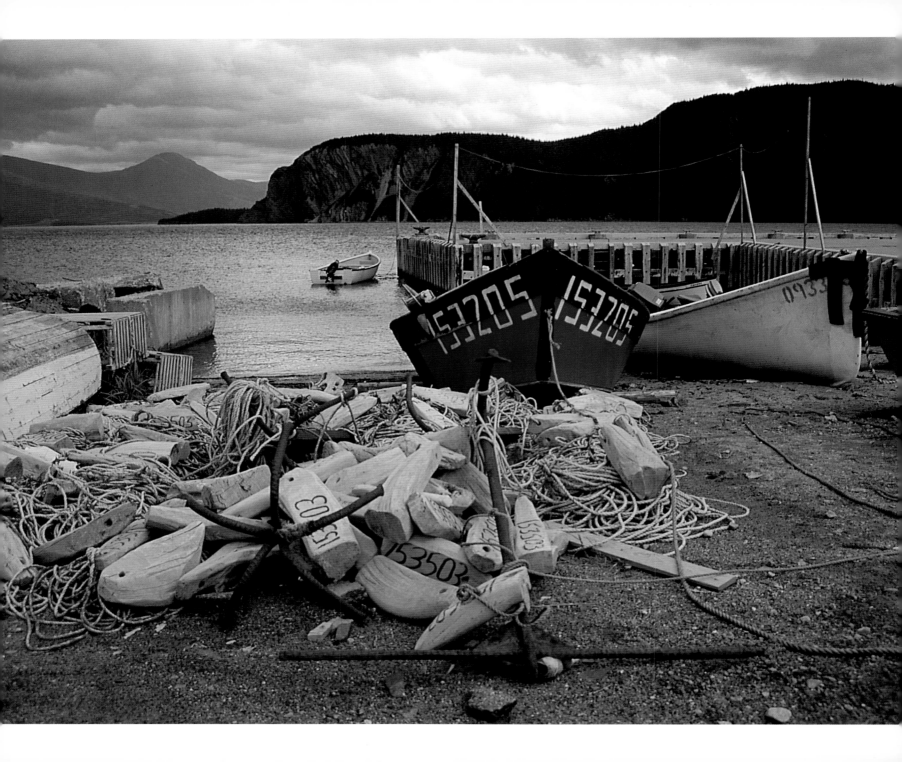

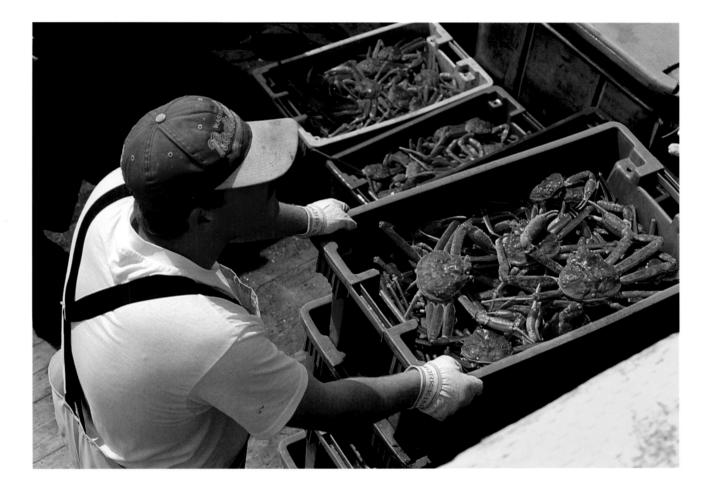

ABOVE: Crab fishery at Codroy.

OPPOSITE: Norris Point, in Gros Morne National Park.

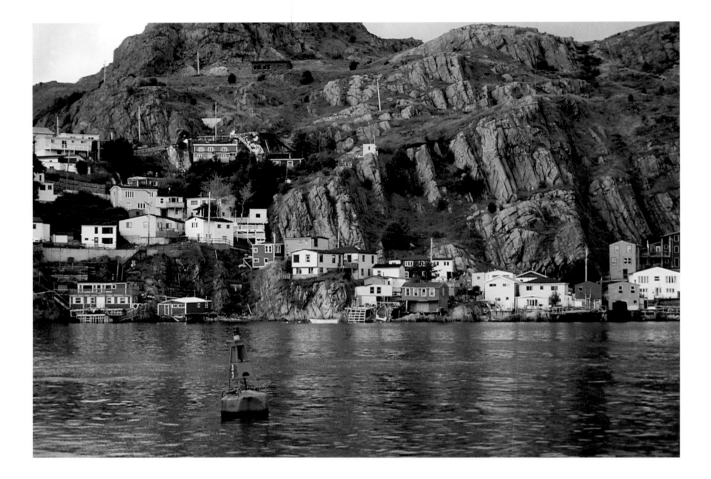

ABOVE: ALTHOUGH IT IS IN DOWNTOWN ST. JOHN'S, THE BATTERY MOST RESEMBLES AN OUTPORT COMMUNITY.

OPPOSITE: ST. JOHN'S HARBOUR AS SEEN FROM SIGNAL HILL, WHERE, ON DECEMBER 12, 1901, MARCONI RECEIVED THE FIRST TRANS-ATLANTIC TELEGRAPH SIGNAL.

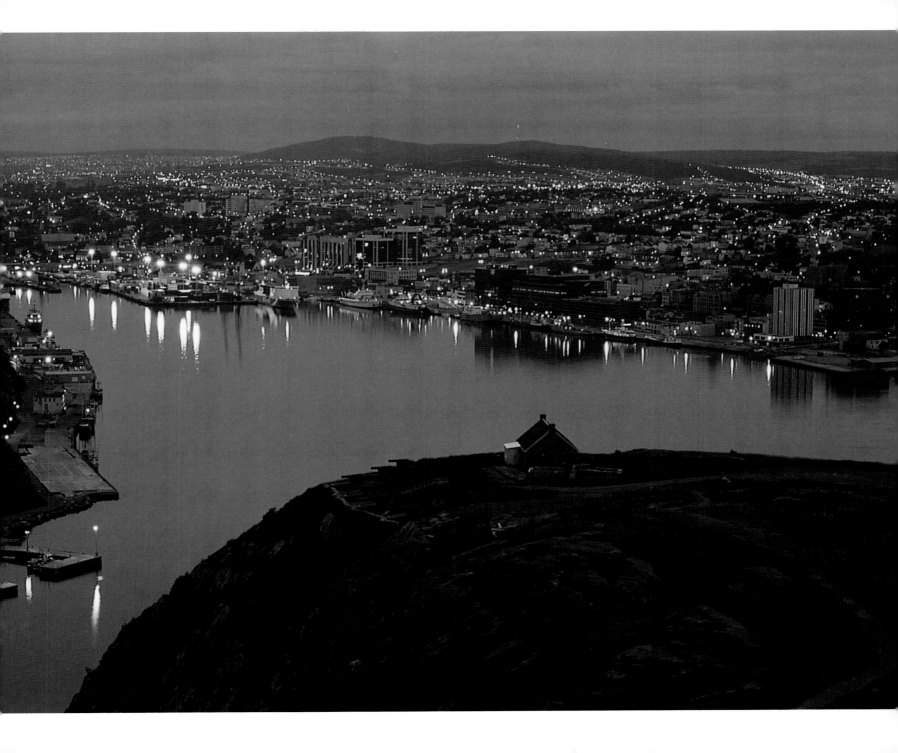

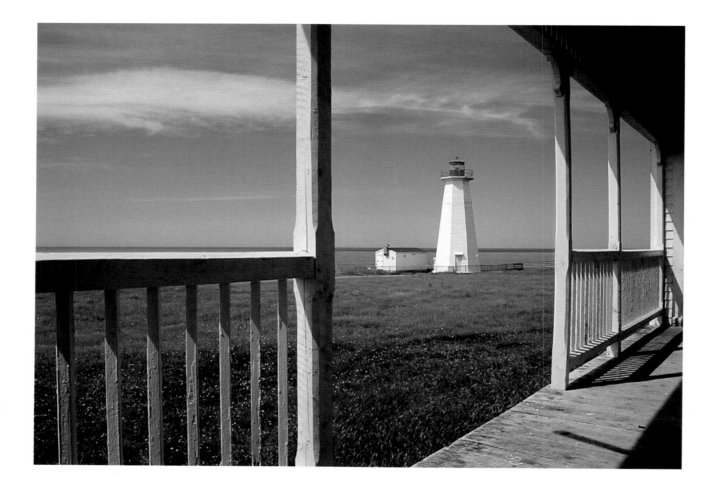

ABOVE: THE LIGHTHOUSE AT CAPE ANGUILLE, THE WESTERNMOST POINT OF NEWFOUNDLAND, WAS BUILT IN 1908.

OPPOSITE: ICEBERG OFF LONG POINT.

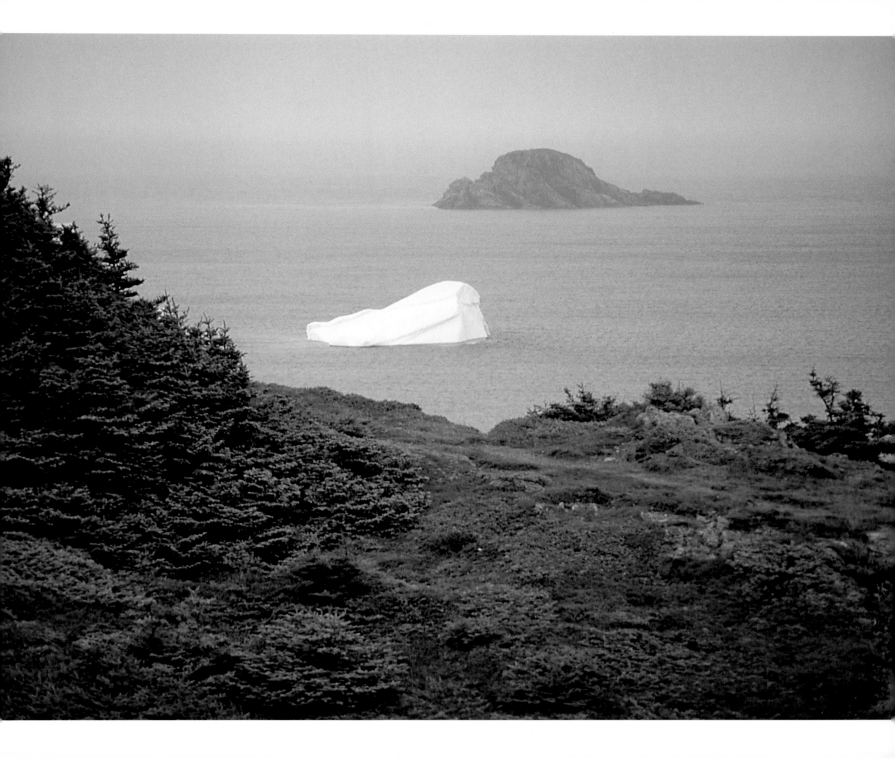

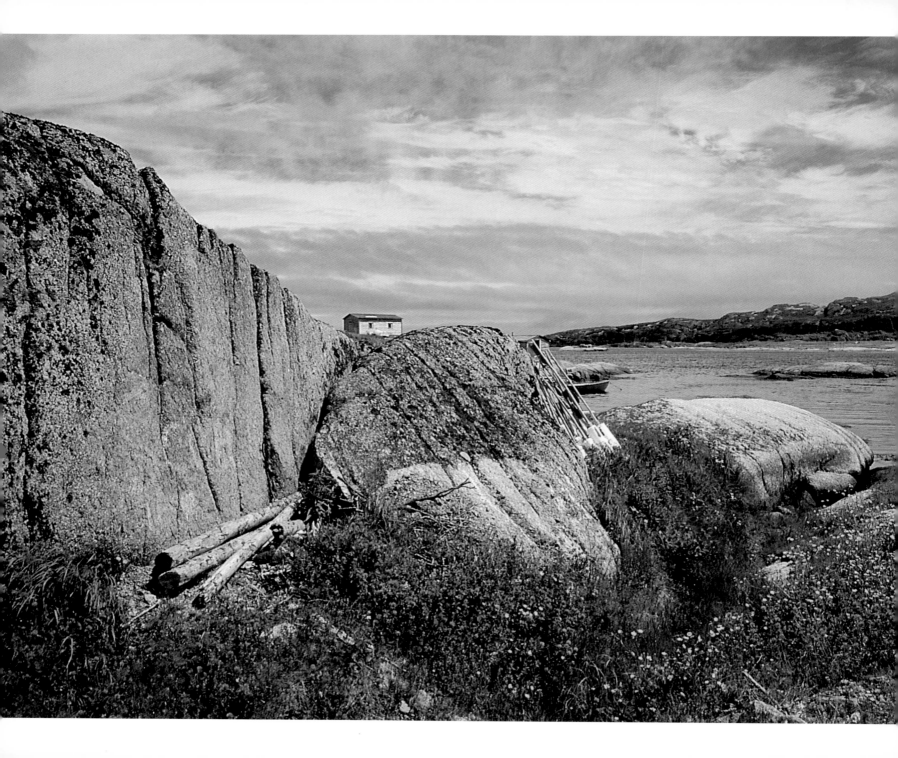

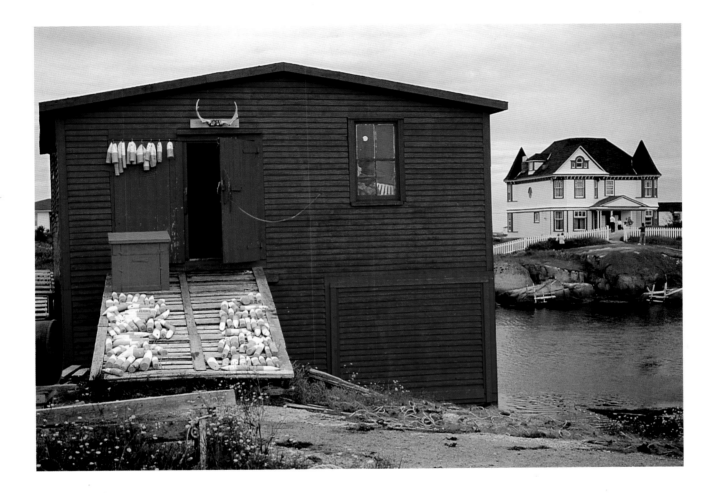

ABOVE: CAPTAIN ALPHAEUS BARBOUR'S HOUSE AND STORE IN NEWTOWN.

OPPOSITE: BADGER'S QUAY ON THE ROCKY SHORE OF BONAVISTA NORTH AT POOL'S ISLAND.

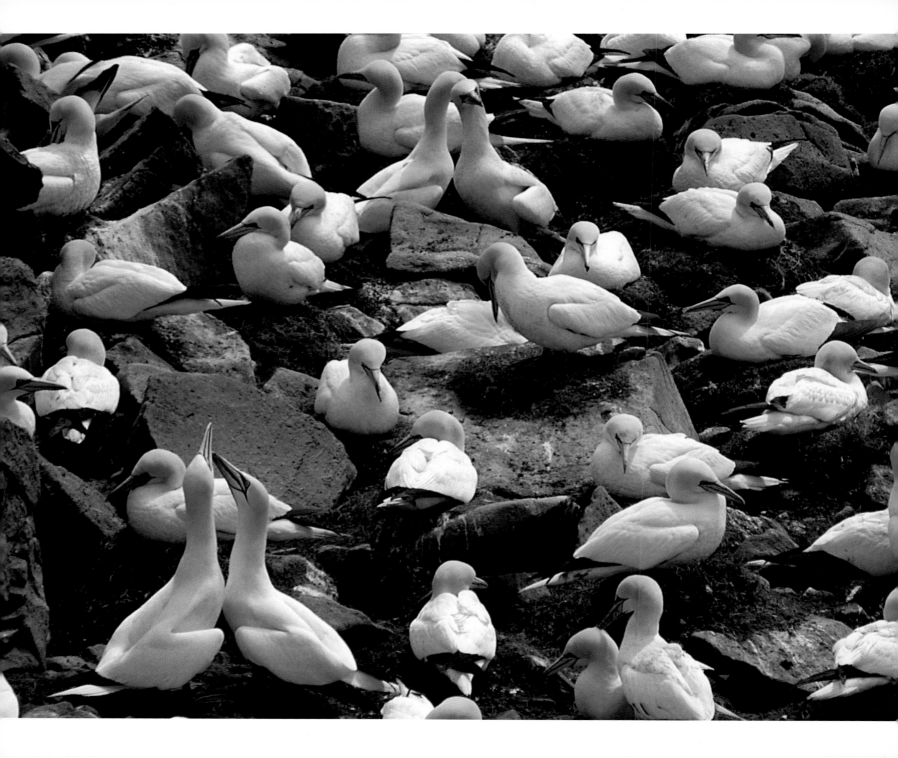

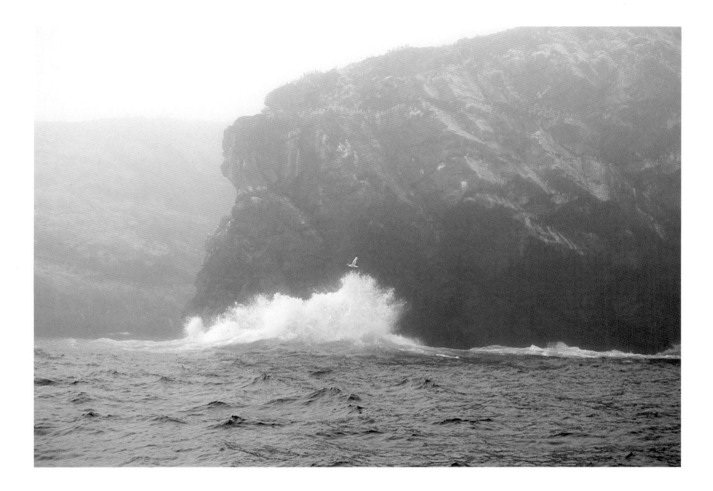

ABOVE: THE BIRD SANCTUARY ISLANDS ARE A POPULAR BOAT-RIDE ATTRACTION.

OPPOSITE: AT CAPE ST. MARY'S, A LARGE COLONY OF GANNETS NESTS IN TOTAL SAFETY ATOP A HUGE FREE-STANDING ROCK,
EVEN THOUGH THE GAP IS NO WIDER THAN 7 METRES.

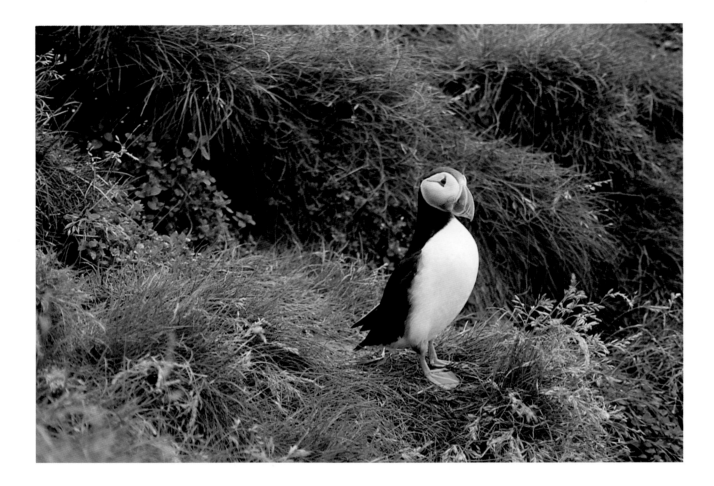

ABOVE: A puffin stands guard at his burrow on the bird sanctuary islands in Witless Bay.

OPPOSITE: Greenspond, in Bonavista North, consists of about a dozen islands, including Puffin, Horse, Pigeon and Maiden.

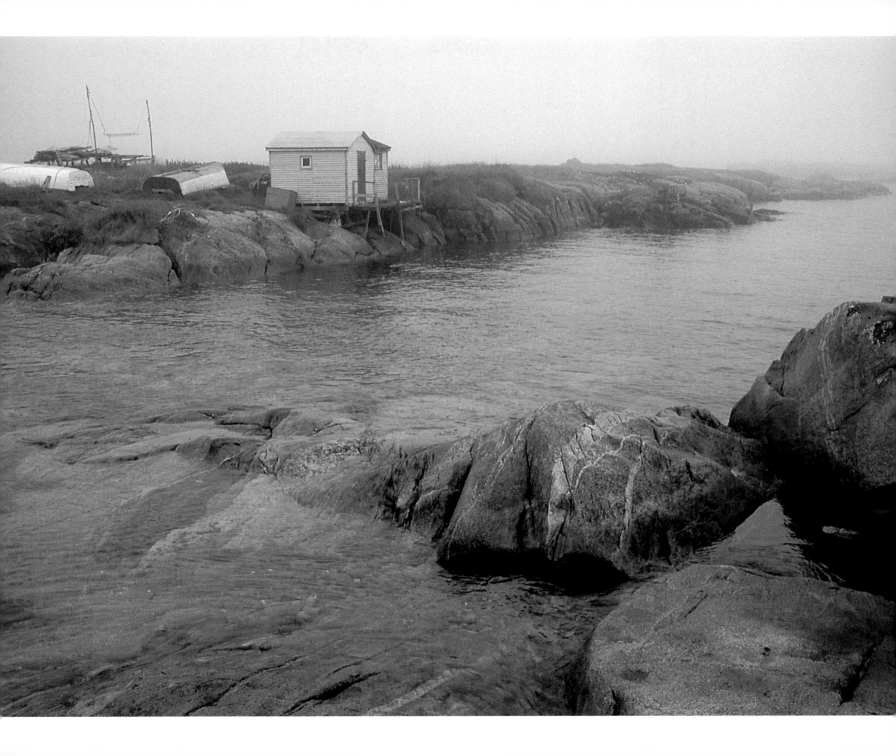

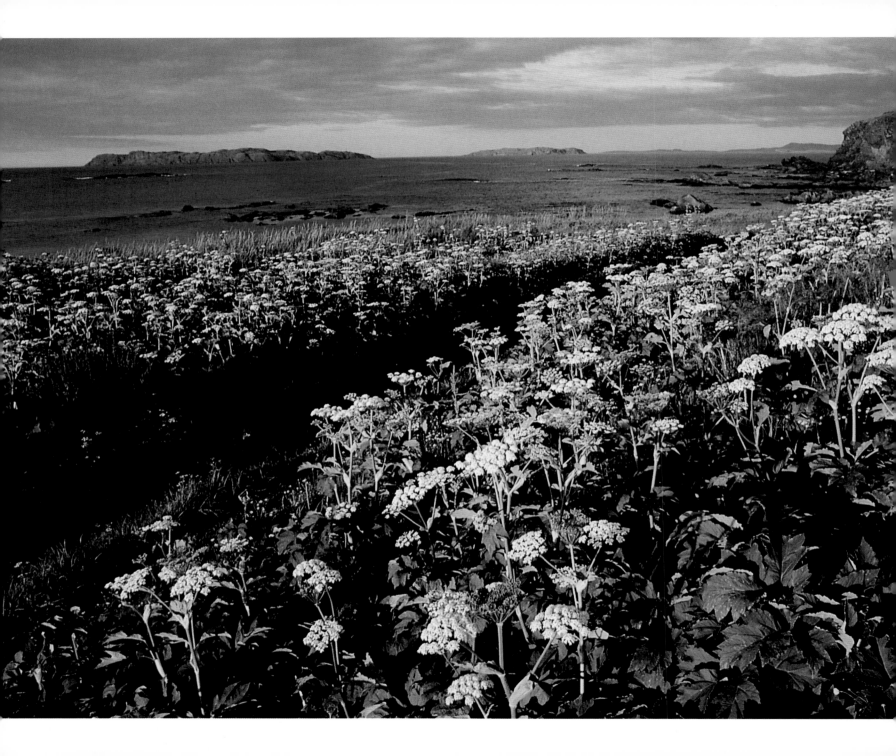

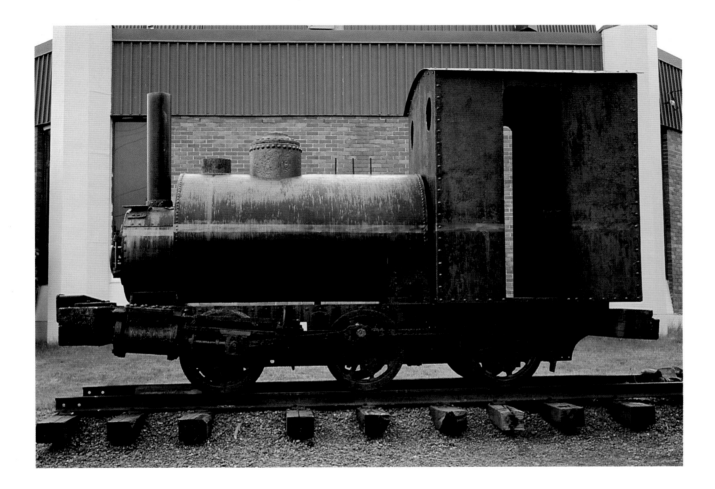

ABOVE: THE OLD YARD ENGINE FROM NEWFOUNDLAND'S FIRST PULP MILL AT GRAND FALLS STANDS NEXT TO THE MARY MARCH REGIONAL MUSEUM, WHICH COMMEMORATES THE 5,000-YEAR HISTORY OF THE BEOTHUK IN NEWFOUNDLAND.

OPPOSITE: THE RUGGED COASTLINE OF THE SOUTHERN AVALON PENINSULA, NEAR GOOSEBERRY COVE.

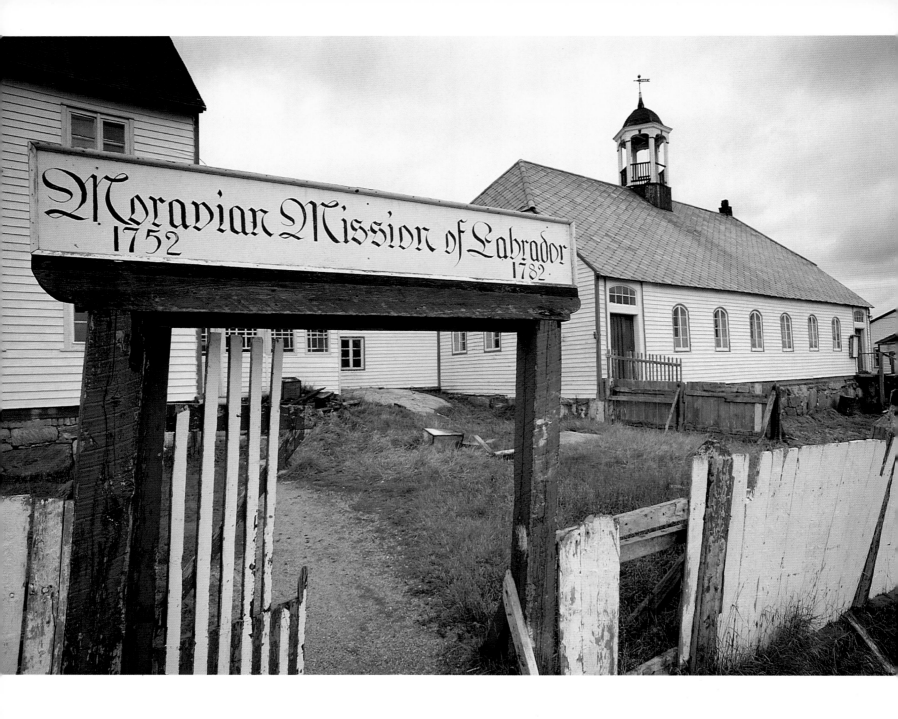

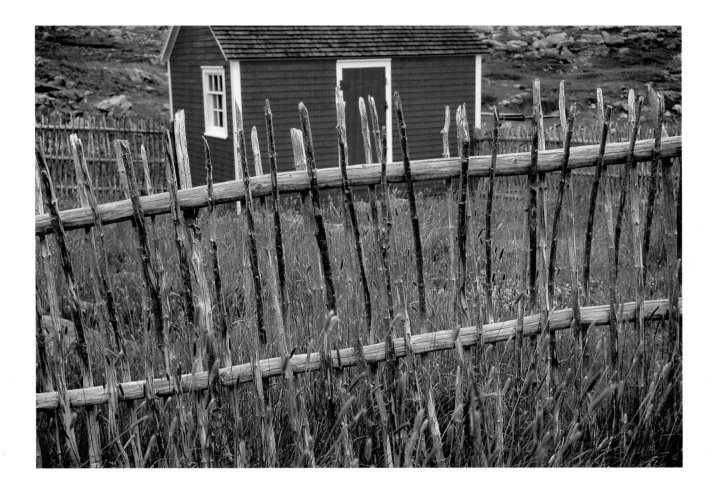

ABOVE: A TRADITIONAL WOVEN-STICK FENCE AND SHED AT CAPE BONAVISTA.

OPPOSITE: THE MORAVIAN MISSION AT HOPEDALE, LABRADOR, WAS ESTABLISHED IN 1752.

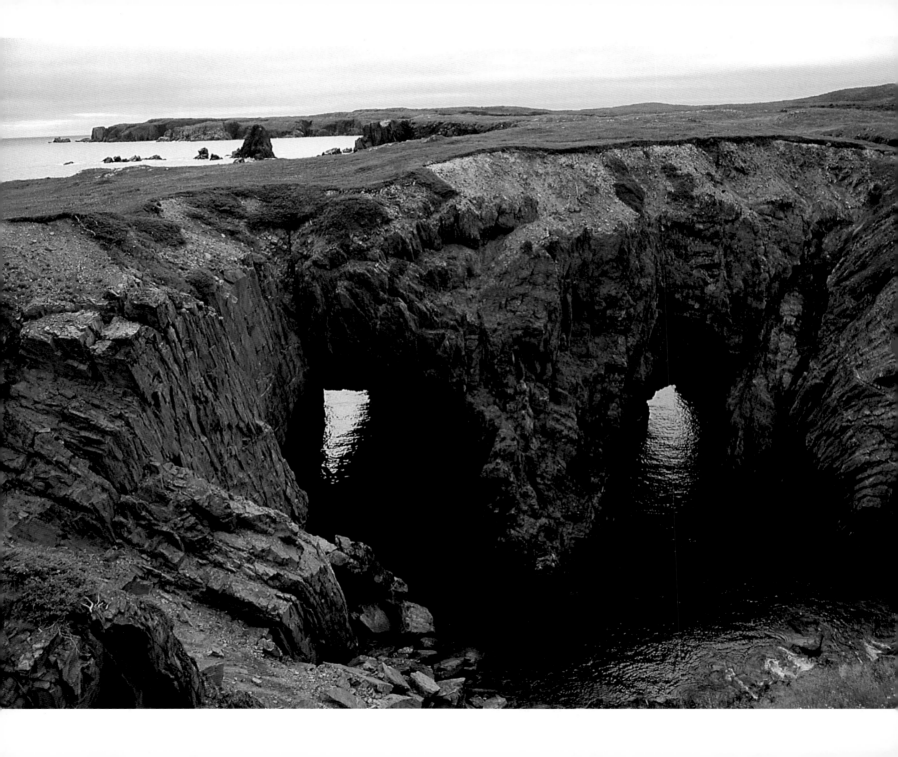

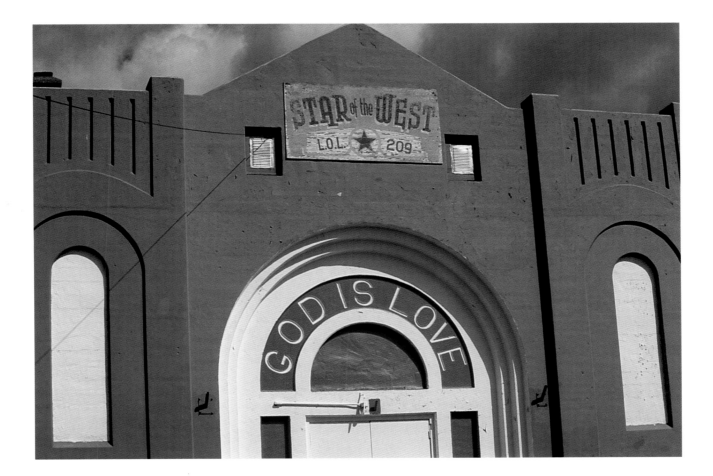

ABOVE: STAR OF THE WEST LODGE IN CORNERBROOK.

OPPOSITE: THESE COASTAL ROCK FORMATIONS APPEAR ALONG THE SHORELINE AT HARRY'S HARBOUR AND NICKEY'S NOSE COVE.

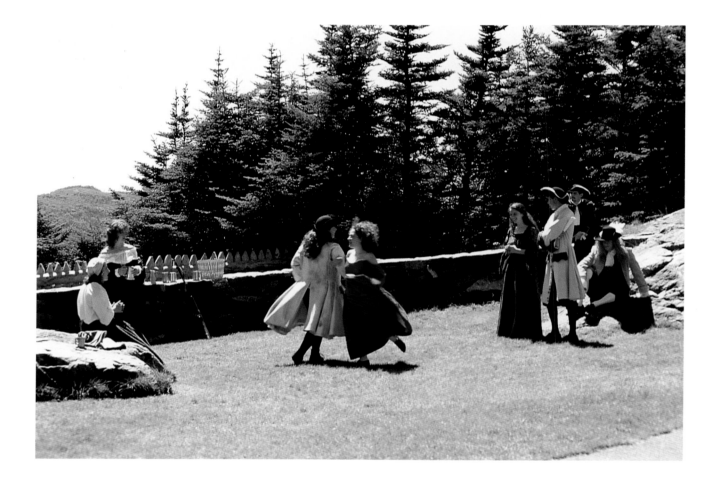

ABOVE: IN THE SUMMER, A PAGEANT BASED ON PLACENTIA'S HISTORY IS PERFORMED AT FORT ROYAL ON CASTLE HILL.

OPPOSITE: PLACENTIA IS OFTEN REFERRED TO AS THE OLD FRENCH CAPITAL OF NEWFOUNDLAND.
NAMED BY THE BASQUES, IT WAS CALLED "ISLE DE PLAZIENCA" ON A 1547 MAP.

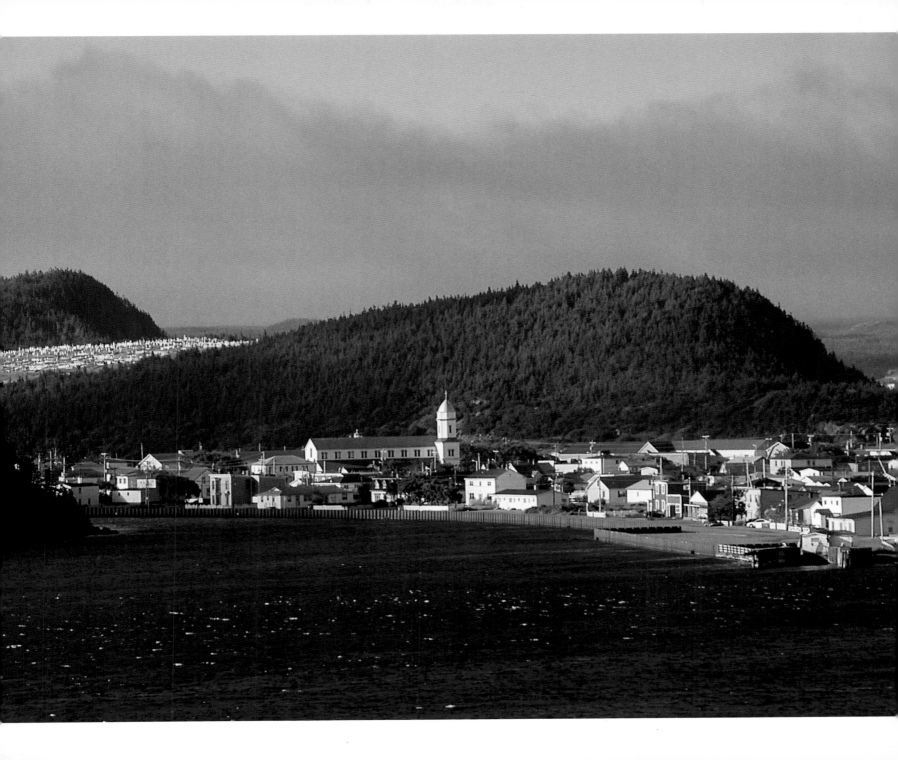

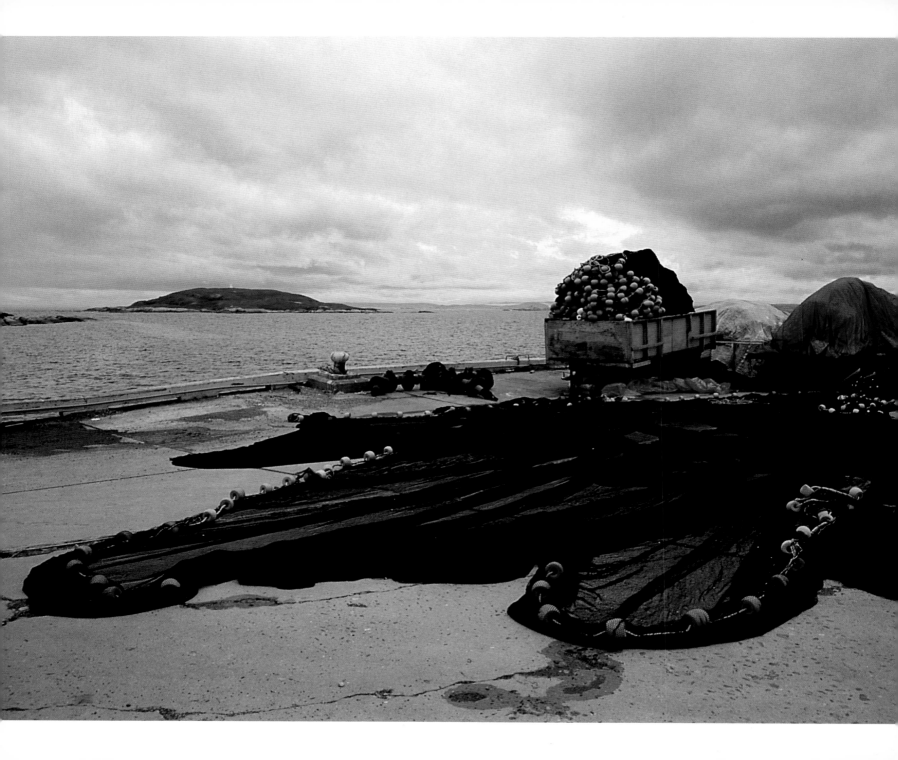

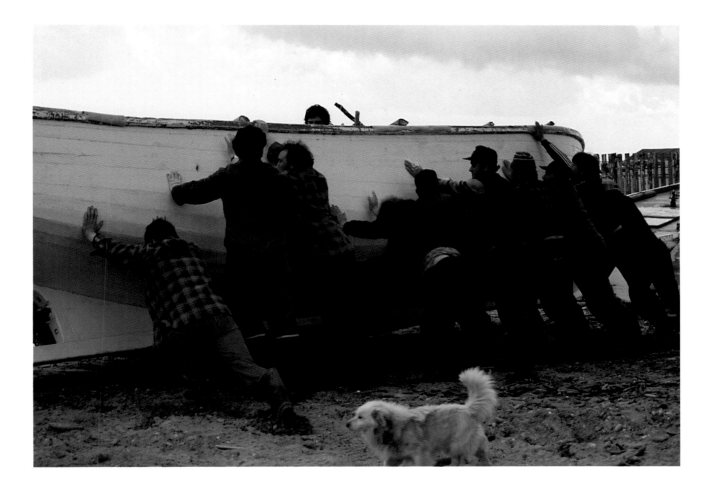

ABOVE: MANY HANDS MAKE LIGHT WORK IN CAPE FREELS, BONAVISTA NORTH,
WHICH MAY HAVE BEEN NAMED BY THE PORTUGUESE AS EARLY AS 1506.

OPPOSITE: WESLEYVILLE IS THE CENTRAL COMMUNITY OF BONAVISTA NORTH. SOME OF THE GREAT NAMES
IN NEWFOUNDLAND MARITIME HISTORY — CAPTAINS KEAN, WINSOR, BLACKWOOD, BARBOUR AND KNEE — CAME FROM HERE.

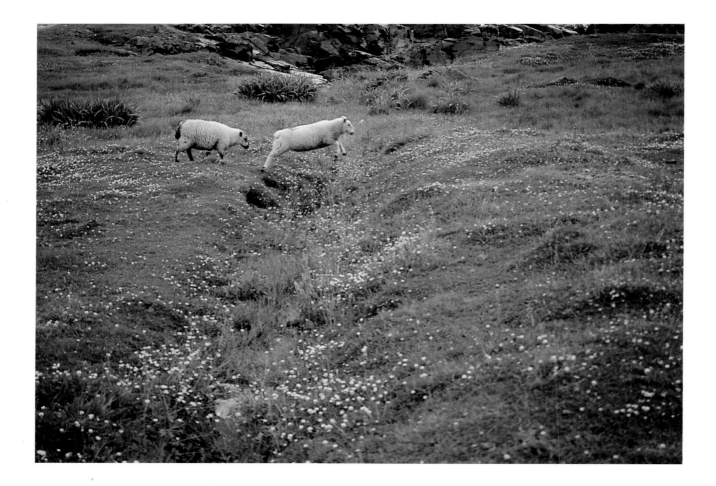

ABOVE: Sheep are well suited to the Newfoundland terrain.

OPPOSITE: The Wesleyville studio of David Blackwood, one of Canada's great painters and printmakers.

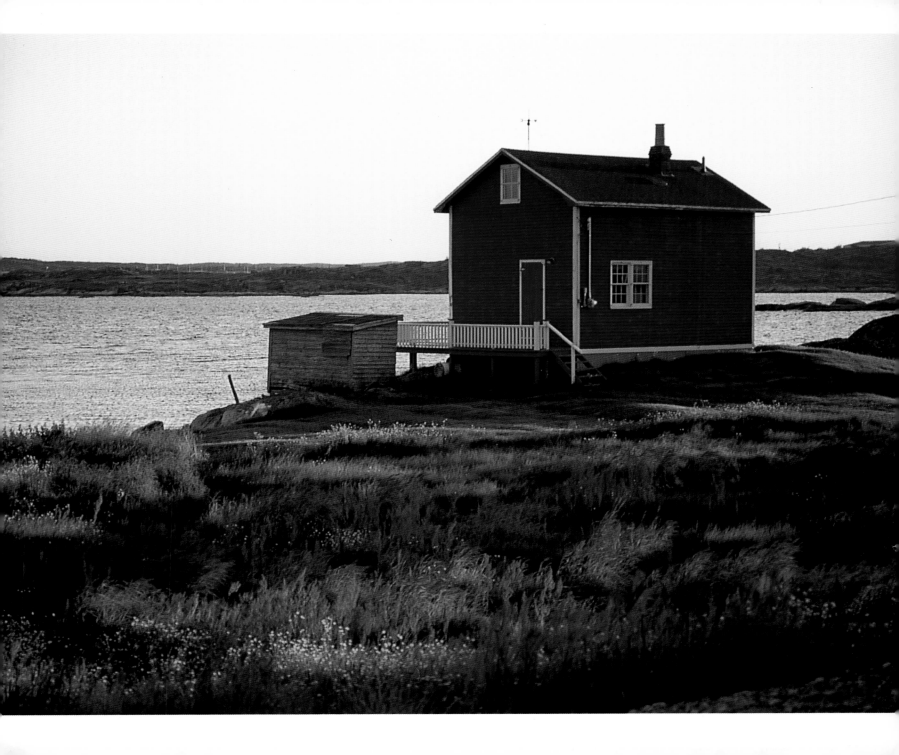

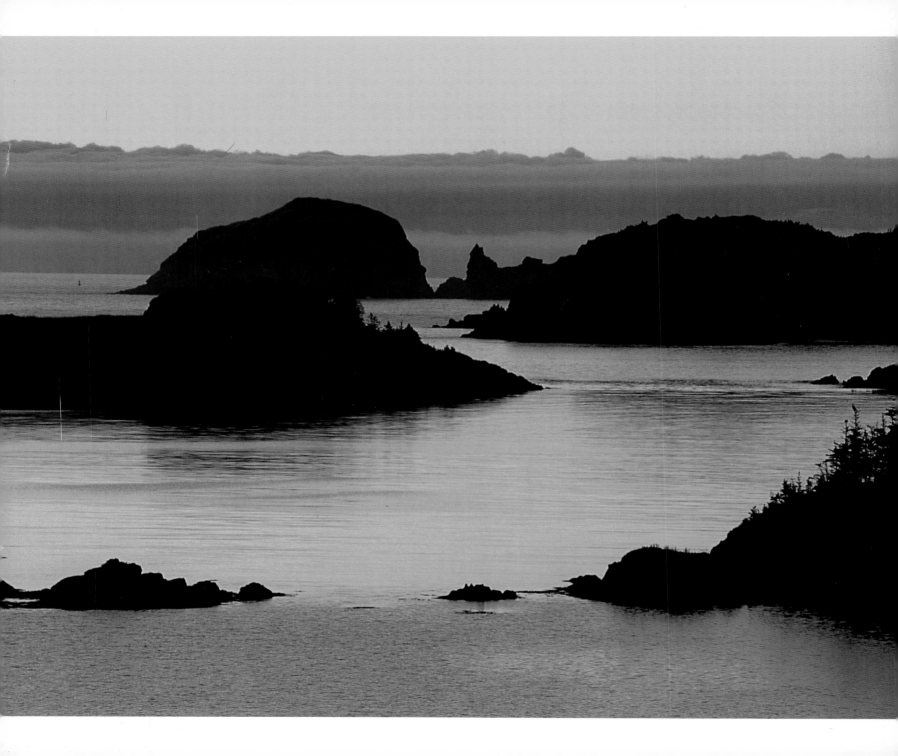